GREEK AND ROMAN
ARCHITECTURE

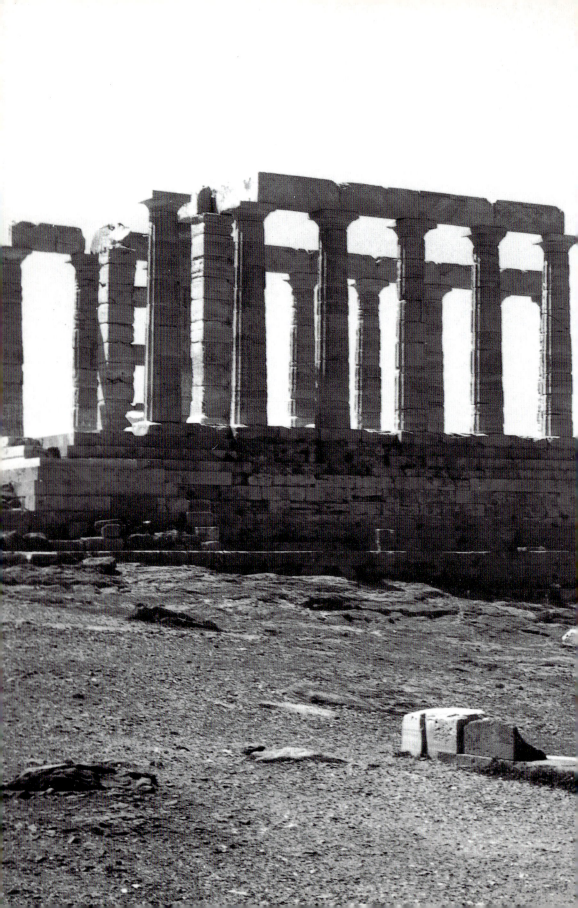

R. A. TOMLINSON

GREEK AND ROMAN ARCHITECTURE

Published for the Trustees of the British Museum
by British Museum Press

Acknowledgements

This book was written in the library of the British School at Athens, and my first debt is to that institution, which provides such splendid facilities for all who wish to study Greece, and above all to its officers, particularly the Librarian, Penny Wilson-Zarganis. I am deeply grateful to the British Museum Press for suggesting that I write it, and to Sarah Derry for her efficient and most helpful editorial support.

Published by British Museum Press
A division of British Museum Publications Ltd
46 Bloomsbury Street
London WC1B 3QQ

R. A. Tomlinson has asserted his right to be identified as the author of this work

ISBN 0-7141-2204-1

A catalogue record for this book is available from the British Library

Designed by John Hawkins
Cover designed by Grahame Dudley Associates

Typeset in Linotron Garamond by
Rowland Phototypesetting Ltd, Bury St Edmunds, Suffolk
Printed in Spain by Grafos SA, Barcelona

Front cover: The Corinthian columns of the Temple of Zeus Olbios (*c.*175 BC) at Olba in Cilicia (Uzunçaburç, south-east Turkey)

Frontispiece: The Temple of Poseidon at Sounion (*c.*436 BC)

Contents

The Origins of
Classical Architecture

To the classical world, architecture meant much more than the mere construction of buildings. 'Architecture', says the Roman architect Vitruvius, writing a treatise dedicated to the emperor Augustus, 'consists of Order, and of Arrangement, and of Proportion and Symmetry and Propriety and Distribution.' For several of these terms he gives a Greek equivalent: his ideas and definitions probably derived from an earlier Greek authority whose writings are lost to us. Utility and Function are not part of this definition, though in his book Vitruvius does go on to describe the best form and arrangements for different purposes of structure; but here, at the beginning, the aesthetic emphasis, architecture as an art, has priority. In this there is continuity, from the earliest Greek and Roman buildings, through various stages of evolution and transformation, into the medieval world and beyond. Subsequently, in the Renaissance, the classical forms of Rome (and, eventually, when they were rediscovered, Greece) were revived, and even if rejected by Goth and Modernist, they still make a contribution to the architectural debate at the present day.

The origins of classical architecture are complex. There was obviously a long prehistory of basic construction, of hut habitations simple in form and material, both in Greece and Italy, which did not match up to Vitruvius' artistic requirements. Though these were, by definition, unartistic they nevertheless contributed an essential element of form which persisted into the later sophisticated architectural concepts. However ornate it may appear from the outside, in essence the classical temple is a simple, single-roomed hut. The elaboration may have been borrowed from elsewhere, from the developed architecture of the Near Eastern cities and, above all, from Egypt, whose traditions and archi-

Fig 2 Opposite
*Roman concrete with
brick facing at the
Palace of Domitian on
the Palatine, Rome.*

Fig 3 Opposite,
below *View of the
'Palace of Minos' at
Knossos (as partly
reconstructed by Sir
Arthur Evans).*

tectural ideas went back much further in time. The mixture varies, but all this is nothing more than a starting point. Classical architecture was surprisingly inventive, and borrowed ideas formed little more than an inspiration for development which came from the classical architects themselves. This may seem surprising; to the outsider the classical in architecture is virtually synonymous with conservative. For long periods, it is true, classical architects seem to have been dedicated to the refinement – and repetition – of ideas worked out by earlier generations. But this was interspersed with times of great inventiveness and innovation. In particular, new techniques and materials led to architectural development and change, even though, once change had been made, the classical demand was again for our timeless Vitruvian qualities. Three such occasions are of particular significance. First, the transformation of roofing materials, probably at the turn of the eighth and seventh centuries BC when, in mainland Greece, thatch – light in weight and easily supported by relatively unsubstantial structures – was replaced by massive and heavy tiles of terracotta, requiring more substantial support and so encouraging the development of larger and more solid buildings. Secondly – and as a consequence of the first, so that it happened within a century – the adaptation of stoneworking and masonry techniques, borrowed from Egypt, to the new forms of building in Greece, the Greek colonies in Sicily and Italy, and thus, after some time-lag, to central Italy, to the cities of the Etruscans and Rome. Thirdly, the development of concrete as a basic building material, in Italy and at Rome during the second century BC, and with this, from the late first century BC onwards, the association of

Fig 1 *The temple-
model from the
sanctuary of Hera,
Perachora. This is a
reconstruction based on
fragments of several
models.*

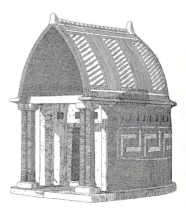

a

b

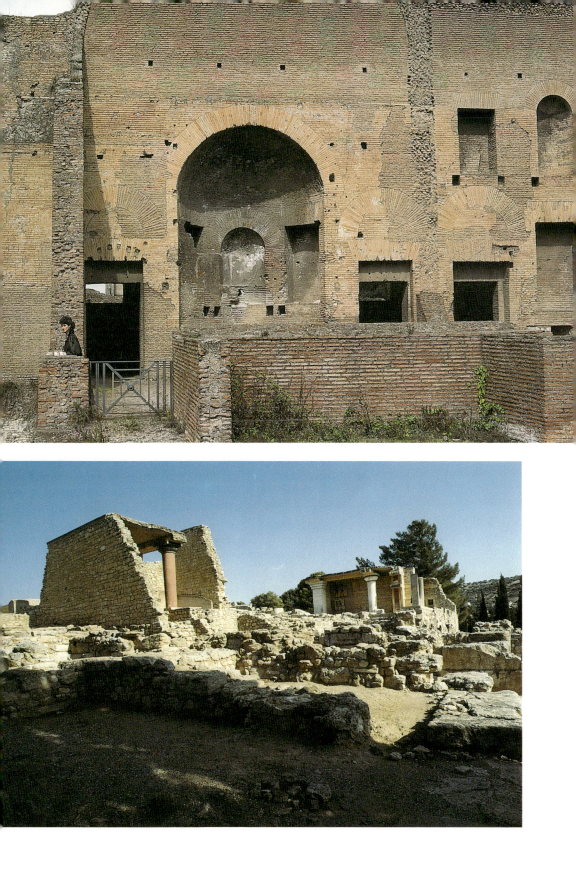

Fig 4 *Plan of the mainland (Mycenaean) palace at Tiryns.*

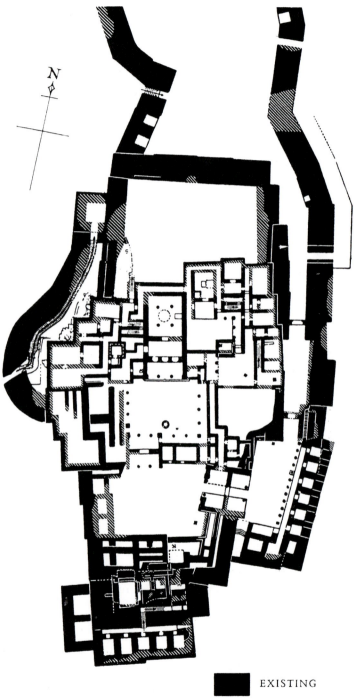

 EXISTING

RESTORED

fired brick as a facing, which led to new concepts of architectural space and, indeed, a change of emphasis from the exteriors to the embellishment and management of interiors as the prime architectural requirement. All three of these developments took place within the classical world itself, and were a result of its own particular architectural genius.

The Bronze Age

The first developed architecture of Greece was created during the Bronze Age of the second millennium BC, firstly on the island of Crete, secondly on the mainland. This was associated essentially with political systems which involved some form of centralised authority, presumably monarchical, and which required sophisticated buildings as an expression of power and an adjunct of administration. This created complex structures invariably termed palaces, both in Crete (where a distinctive planning system was applied to them, resulting in structures which must have contributed to the later Greek memory of them as labyrinthine, long after they had been destroyed) and on the Greek mainland. These mainland buildings borrowed the Cretan courtyard arrangement, but included in this as the principal focus a large rectangular room, its side walls prolonged to form an open porch, invariably described by modern archaeologists (who borrow the term from the later poems of Homer) as a *megaron*. In essence a transformed but traditional hut, already found in the earliest Bronze Age, this form continued as a hut after the destruction of these prehistoric palaces. Other important architectural concepts are found in the tombs, especially the (presumably) royal tombs on the mainland, built of stone as a corbelled dome in the form of a traditional beehive (and imitated, for less important persons, as rock-cut chambers). Finally, as the political stability of the late Bronze Age declined, massive fortifications of megalithic structure were thrown round the principal palaces of the mainland. None of this is found in Italy, and even in Greece, despite the fortifications, by the eleventh century BC the palaces were destroyed, and the area subsided into what could be described as primitivism.

It is unlikely, therefore, that the architecture of the Bronze Age

Fig 5 *The entrance passage to the greatest of the Tholos tombs at Mycenae, the so-called 'Treasury of Atreus' (photographed in 1953).*

had any real influence on that of the succeeding centuries, either in Greece or Italy. In both areas, communities were small, better described as villages than towns. In Greece there is evidence for the introduction of a 'horseshoe'-plan hut, with a porch at one end but closed by a curved wall at the other. An exceptionally elaborate example at Lefkandi, on the island of Euboea, was over 100 feet in length, and had, except it would seem at the front, an external colonnade of wooden posts to help support what must have been a thatched roof. It was very short-lived, demolished almost as soon as it was completed, and functioned as a burial place, in two shafts dug at its centre, for a wealthy individual and his wife, in one shaft, and his horses in the other. This dates to the early tenth century BC. It is a strange structure for a tomb, particularly as it was, apparently, dismantled after the burial and covered with a more conventional burial mound. It looks as though it ought to have started life as a substantial, that is, a ruler's house, but it is situated in a cemetery area, not a settlement. Perhaps it reflects the actual house in which the dead man lived. Though its colonnade resembles later temple form, it is too remote in time for even the earliest developed temples to have had

any direct influence. The simplest explanation is that both this and the later temples are variants of the then normal house – or at least the house that was normal for people of superior position. Thus the Lefkandi structure can be seen as the home of the powerful dead, the temple as the home of the powerful immortals, the gods.

The earliest temples

The idea of the temple seems slightly later in origin, the earliest known being attributable to the eighth century BC in Greece and somewhat later in central Italy. Some, such as the first temple of Apollo Daphnephoros at Eretria, not far from Lefkandi, and the first temple of Hera at Perachora, near Corinth, had the curvilinear form, with a quasi-apsidal end, and a porch at the front. Little remains at either, but Hera at Perachora was also given what appear to be terracotta models of her temple, indicating a superstructure with walls of mudbrick, plastered and decorated with a painted maeander pattern, and a roof which was clearly of thatch. Eretria also must have been thatched; there the walls were reinforced with wooden posts set against them both inside and outside. Both these buildings were still small – the building at Eretria was about 11 × 7.5 m only – and cannot have had a long life, unless they were constantly repaired. Neither can have been different in form, or much more substantial, than the houses of the same period, though few of these have been recognised or excavated. Perhaps the temples were more regular, more disciplined in their arrangement, so that they can be regarded as the forerunners of true architecture; but in the Vitruvian sense, they are not yet architectural. Many contemporary huts may well have been even more formless, though this was probably all that distinguished them from the temple buildings.

The next stage, in the first half of the seventh century BC, is represented by two major buildings, the temple of Poseidon in his sanctuary at the Isthmus of Corinth (Poseidon Isthmia), and that of Apollo in Corinth town. Both were replaced by later buildings, but enough survives, particularly of Poseidon's temple, to give us some idea of their arrangement. Both were much larger: the foundations of Poseidon indicate overall dimensions of 40 × 14 m. Poseidon, certainly, had

walls which were constructed from squared ashlar stone blocks, though they retained a patterning which seems to reflect timber-laced mud-brick construction. Above all, both temples were roofed with heavy terracotta tiles, which combined a main, slightly concave section with an angled attachment along one side to cover the joint between one tile and its neighbour. Each tile weighed about 25 kilos, and would obviously have needed massive timber work to carry the roof. This must have been extended beyond the wall to an outer colonnade, presumably still timber, since no traces of it survive (its existence has been doubted, but the dimensions of the tiles, and so of the total roof require it). 'Two-way' tiles prove that one end of each temple, at least, was hipped rather than in the gabled form inevitable in later Greek temples, perhaps suggesting an inheritance from the apsidal form of the eighth-century buildings. Poseidon is the earlier, somewhat before 650 BC; the roofing systems are so sophisticated that there must have been antecedents, but these have not been identified, and it is not clear whether they were invented in Greece, or copied from elsewhere.

Terracotta tiles, and revetments to cover wood or mudbrick elements are soon found elsewhere in the Greek world, in north-west Greece where they were once thought to be imports from Corinth but now appear to be of local manufacture, and in the Greek colonies which were founded, from the eighth century onwards, in Sicily and southern Italy. In these areas the terracotta revetments became particularly elaborate, using the patterns – cable, lotus bud and palmette – which Greek art (particularly the painted vases) was borrowing and adapting from the Near East at the time. Elaborate terracottas, with similar patterns, typically survive from the earliest temples built by the Etruscans in their central Italian cities, and at Rome which for a time was under Etruscan domination. Early Etruscan temples share other characteristics with the early Greek temples. They are rectangular (often square) in plan, with rooms, single or in triplets depending on the cult, behind porches which occupy half the depth of the building. They do not use the form with surrounding colonnades already seen at Isthmia and Corinth, and stand on fairly high bases (podia) which are stepped only at the front. This regional variation seems to have developed already at the earliest stage.

Fig 6 *Terracotta antefixes from the Greek colony at Taras (Taranto).*

Fig 7 *Etruscan*
terracotta revetment.

The classical orders

The temple at Isthmia foreshadows the next major development, construction in stone even for the colonnades and their superstructures, or entablatures. By the end of the seventh or the first part of the sixth century BC it is possible to recognise in Greek stone-built temples the definitive 'orders' which distinguish their colonnades, and which are fundamental to classical architecture in the Vitruvian sense. The Doric order emerged on the mainland of Greece, the home of the Dorian Greeks. It probably originated in Dorian Corinth (though it spread to other mainland non-Dorian cities such as Athens) and from its form must have developed in wooden architecture before its translation into stone; so it is likely to have been used for Poseidon Isthmia, but since nothing there survives, this cannot be proved. The other principal order is the Ionic, which developed in the Ionian cities of the Cycladic islands of the Aegean, and settlements on the coast and offshore islands of Asia Minor (now Turkey, and the adjacent Greek islands). There is also a variant form ('Aeolic') on the islands of the north-east Aegean and the adjacent mainland.

The idea of using stone for columns would have become familiar to the Greeks in the course of the seventh century, when traders and soldiers first travelled to Egypt. The techniques of stone carving (for sculpture as well as architecture) and for turning columns which are circular in section, were introduced to Greece particularly during this period. In the Doric order, there is little evidence of experimentation, and the form must have been worked out in its wooden prototypes. The earliest columns seem to have been slender, like coniferous tree trunks, but almost immediately became thicker and heavier, more like Egyptian columns – probably as a result of the inadequacies of the limestone employed for them (Ionic, on the other hand, from the outset used marble, and remained much more slender). The early columns are monolithic, and were cut from the quarries using the same techniques that were used for the large stone statues which were a contemporary development in Greek art. The Doric entablature is distinctive; an architrave with a projecting band along the top, sur-mounted by a frieze of flat squares separated by raised panels which are divided into three vertical strips by a couple of V-section grooves. The Greek term for these panels is *triglyph*, while the squares between them are called the *metopes*. Their wooden origin is clear. The triglyphs coincide with projections below the band at the top of the architrave, and include representations of what must originally have been pegs driven through to hold them in place. The triglyphs may be on a separate block from the metopes which originally were slabs of terra-cotta (actual examples survive from a presumably wooden entablature at Thermon in north-west Greece). Similar pegs in boards exist under the cornice, probably to hold roof elements in place. The pattern of triglyph and metope can be seen in representations on Greek vases of wooden chests. The actual pattern is hardly structural in origin, and may well represent the translation, first in the wooden entablatures, of decorative systems found as patterns on pottery and certain Near Eastern ivories. (These pottery and ivory examples also feature the lotus and palmette designs found in Greek architecture, either carved or painted on mouldings or on the terracotta revetments.) The Doric order is normal in the Greek temples of the west, but does not seem to have been adopted by the Etruscans, who had a simplified structure elaborated by the terracotta revetments.

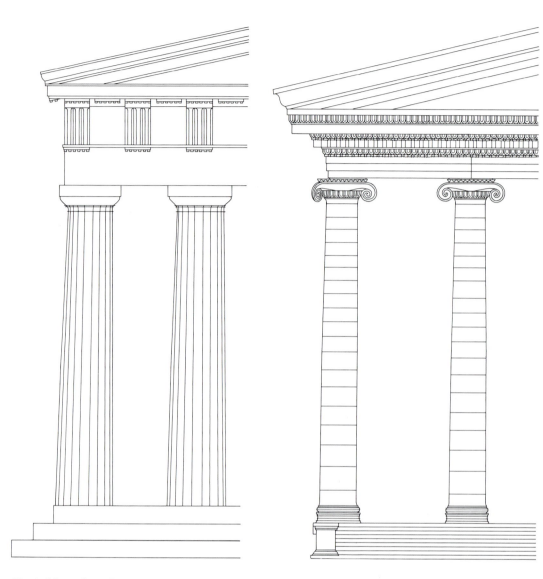

Fig 8 *The 'orders' of classical architecture. From left to right, classical Doric (the Parthenon, Athens); 'Asiatic' Ionic (the Temple of Hera, Samos); Hellenistic Ionic (the Temple of Artemis, Magnesia); and Roman Corinthian (the Temple of Castor, Rome).*

In the East Greek area, Ionic is more variable. The essential characteristic is the volute capital, more richly ornamented than the plain Doric which has only the circular-plan spreading section (the echinus) capped by a square bearing element (the abacus). In Ionic, between an ornamented echinus and (if it exists) a thin abacus come pairs of scroll volutes, facing front and back, and linked to form a single 'volute member'. In Aeolic, however, the scroll volutes spring separately from a central triangle and this betrays their origin; they are essentially a Near Eastern form, perhaps borrowed directly from the architecture

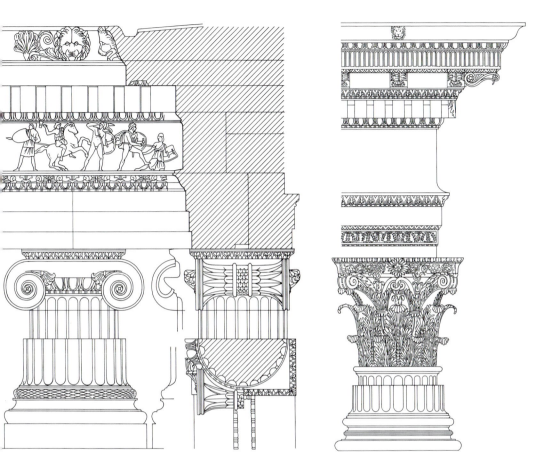

of Syria and the Phoenician cities, or copied from representations in ivories and other works of art. Aeolic is closer than Ionic to the Near Eastern originals. Architraves are plain, or divided into horizontal bands, each projecting outwards a little more than the one beneath. At this stage there is no frieze above this, but a series of projecting rectangular blocks (dentils) which look like small beam ends. Unlike Doric, the underside of the cornice is plain. Ionic buildings soon developed the use of marble slabs for tiles.

Thus the outward appearance of major Greek buildings (which at this time meant essentially the temples) emerged rapidly in the late seventh and early sixth centuries BC in forms which remained an essential feature of classical architecture for over a millennium, and which continued in the post-medieval revival of classical form. The

only significant development was the creation of the Corinthian order in the fourth century BC, taken up particularly by Roman architects yet even this was only a modification, restricted to the capital, of the earlier Ionic. It was the Greek architects of the seventh century BC who determined, at least in generality, the Vitruvian requirements of true architecture.

CHAPTER 2

Greek Temples

Architecture in the Vitruvian definition developed in Greece and Rome when it became possible, desirable and, indeed, necessary to devote substantial resources to building, to create structures which were more than utilitarian in concept and material. The original compulsion was religious: the need for the early communities to pay proper respect to the gods, and to secure their favour. Inevitably, classical architecture in Greece began with the construction of temples (it is noticeable that this is in marked contrast to Greece and Crete in the Bronze Age, when the main architectural emphasis was on the palaces). Temples were not essential to the practice of Greek and Roman religion, which focused on sacrifices, performed in an area dedicated to the gods at an outdoor altar, and watched by large numbers of passive worshippers, who subsequently shared the meat of the sacrificial animals. The temple was itself another offering. It contained the image of the god, which could take various forms, but was generally a statue; and it sheltered other valuable offerings, particularly gold and silver plate, which had to be kept safe. The concept behind the temple was that it represented the home of the god (even if, in actuality, the god was conceived as dwelling on the top of Mount Olympus), and thus in origin it took the basic form of the rectangular hut, even if other types of houses existed. What was important was its embellishment. Even if the building at Lefkandi was not in origin a 'palace', presumably it represented the forms of distinction and embellishment given to the actual house of the man buried in it, and which therefore provided an appropriate form for the house of the even more important god. Once this had been developed, in the course of the eighth and seventh centuries BC in Greece, the form remained constant; this was what was appropriate. It is noticeable that Etruscan temples, and, as far as we can understand them, those at Rome, remained under the strongest influence of the original developed form.

Doric temples

This is not to say that all temples were essentially the same. The normal requirement was a rectangular room and a porch. Only those of the more important cults were given in addition the external colonnades, but it is these major buildings which determine the development of architectural form. There is a Greek term to describe a major temple – hekatompedos, which means a 'hundred-footer', that is, a building around a hundred feet in length. There are of course some which are larger, such as the Parthenon at Athens, which is over 200 feet (the exact length depends on the size of the foot unit – the Parthenon measures 224 'feet' of 0.306 m each, the larger of the foot units in general use in Greek architecture). But normally a length of around 100 feet sufficed for what was considered a respectable temple building.

A good example is the temple of Aphaia on the island of Aigina, started at the end of the sixth century BC, which measures 13.77 × 28.82 m (about 45 × 95 modern feet). These proportions are not standard; most temples are somewhat longer in proportion to their width. For Aphaia's temple, these dimensions give room for a facade of six Doric columns, with twelve along the sides (the corner columns, of course, being counted for both directions). It was built of limestone, the material which was locally available and therefore relatively inexpensive, though to improve its appearance, when the building was complete, its surfaces were coated in a hard white plaster. None of the metopes of its Doric order survive; they may have been made of marble, and subsequently plundered for re-use. Generally, the Doric temples of southern Greece, which would include the island of Aigina, do not have carved decoration on their exterior metopes, but restrict it to those over the porch of the cella (the inner building), and the additional porch at the rear of the cella normal in peripteral temples. In most temples, this porch is 'false' – that is, it has the appearance of a porch but does not actually lead into the building. This was true of the rear porch at Aigina, but subsequently a doorway was cut through from, rather than to the room, at a time when the false porch itself was closed off by means of metal grilles between the side walls and the two Doric columns that were placed between them. This

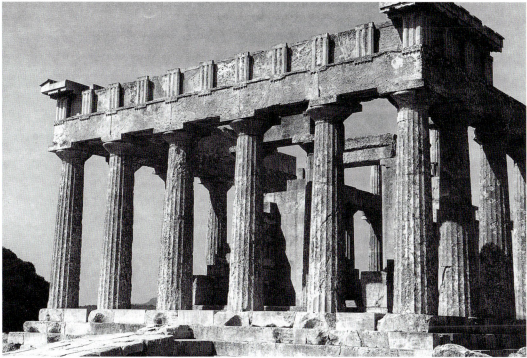

appears to have been done to add extra, secure storage space for the valuable offerings contained in the temple. The cella room had two internal rows of Doric columns dividing it into a nave with two aisles; these were two-storeyed, and served to support the timbers of the roof. The woodwork of all Greek temples remains unsophisticated, essentially depending on beams supported at either end. The free span was thus restricted by the dimensions and strength of the available timber, given the enormous weight of the roof tiles. Beams above six or seven metres in length were difficult to obtain, and temples were usually designed so that this was the maximum length needed; special timber would be required, at special expense, for the larger buildings.

Similar temples in the Doric order were built in the western Greek colonies of Sicily and southern Italy. In general terms these are similar to Aphaia, but close examination will reveal regional differences, local rules for the spacing of the columns, and above all for the general dimensions. Western Greek temples were invariably built of local stone, which is poorer in quality than the limestone used for Aphaia. Columns therefore tend to be thicker and heavier in appearance. The platform on which they stand, which in mainland temples, irrespective

Fig 9 *The east façade of the Temple of Aphaia, Aigina, with some restoration. Traces of white plaster are still preserved.*

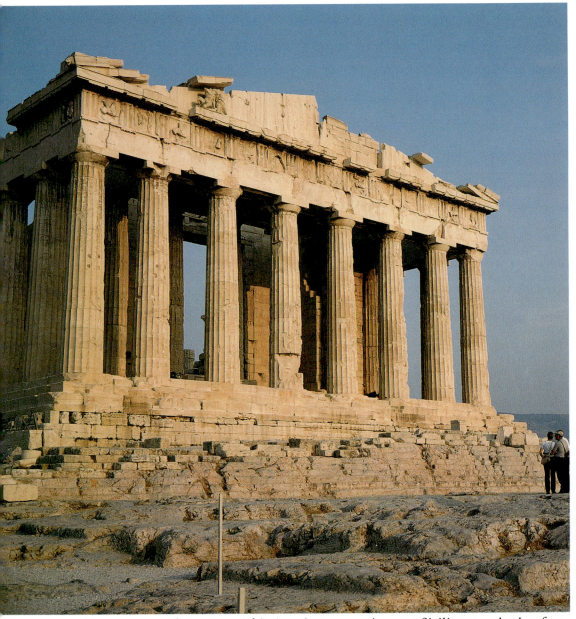

Fig 10 *The Parthenon, Athens, photographed before the recent reconstruction programme.*

of size, invariably has three steps, in most Sicilian temples has four, perhaps to provide a base which is visually adequate to support the heavier columns. Equally the entablature, the proportions of which by convention depend on the diameter of the columns supporting it, had to be made heavier. Thus the temples appear massive, and unrefined in comparison with their developing contemporaries elsewhere.

The local stone has weathered to an attractive golden brown colour, but this is misleading; like Aphaia these temples were plastered when complete. Another feature general in the temples of Sicily (but not those of Italy) is that they have no internal colonnades to support the roof, perhaps indicating that more substantial timbers were available, rather than that a more sophisticated roofing system was employed.

Athens

The culmination of Doric architecture on the Greek mainland is the

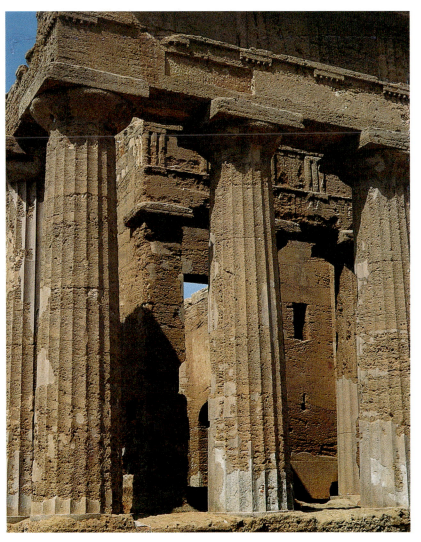

Fig 11 *The so-called Temple of Concord, Agrigento. The stone surfaces would have been stuccoed originally.*

great sequence of temples built by Athens at the height of her power and wealth in the fifth century BC; these were acknowledged as an extraordinary achievement, even at the time of their construction. They were the first, and certainly the greatest temples on the mainland which were built of white marble rather than limestone. Athens was fortunate in possessing local sources of marble, on Mount Pentelicus (Pentelic marble, used for the Parthenon, and other temples in Athens), Agrileza (used for the temple of Poseidon at Sounion), and Ayia Marina (used for the temple of Nemesis at Rhamnous). There is also a more bluish marble available from Mount Hymettus, little used in the fifth century, but of increasing importance in later Athenian architecture. Pentelic marble was quarried high on the mountain, blocks being lowered down a slipway on sleds, and then transferred to wagons to be brought across the plain of Attica to the city and the Acropolis; obviously, some expenditure was incurred, but the marble had the advantage over more local limestones in its brilliant colour and surface, which did not require plastering, its ability to take crisp, clean carving, and its greater tensile strength, which enabled the proportions, particularly of the columns, to be slimmed and refined. At Athens only the second rank of temples were 'hundred-footers' – the temples of Hephaistos in the city itself, Ares at Acharnai, and Poseidon at Sounion; the Parthenon, as the chief temple, is over double this size.

The Parthenon demonstrates clearly the 'showpiece' character of major Greek buildings, designed to impress not only the possessing deity, Athena, who protected Athens, but also ordinary mortals, with the wealth and power of the city. It seems deliberately to have outdone what was till its construction the largest temple of mainland Greece, the limestone (and relatively crude) temple of Zeus at Olympia. Where Zeus had a six-column facade, the Parthenon had eight (though the foundations had been laid, earlier in the fifth century, for a six-column facade). Zeus had thirteen flanking columns, the Parthenon seventeen, even though the overall dimensions were only slightly greater. Where Zeus had carved marble metopes only over the internal porches, the Parthenon had all ninety-two external metopes carved, and in addition a splendid, totally unconventional continuous frieze, representing the great festival procession, replacing triglyphs and metopes over the

inner porches and continuing along the side walls. The surviving portions of this frieze, left after the Parthenon was blown up in 1687, can be seen in the British Museum and the Acropolis Museum at Athens, conveniently close to and at eye level; on the building they were high up under the ceiling of the outer colonnade, difficult to see, and perhaps carved rather for the benefit of the goddess and the glorification of the city and its festival, than for the appreciation of the human viewer. The proportions of the Parthenon were most care-fully worked out, with a ruling ratio of 4:9 (width to length, column spacing to column height, and so on). Such precision and forethought of design had not occurred before, where the design of temples seems to have been based on rule of thumb and local antecedents. The impres-

Fig 12 *The frieze over the west porch of the Parthenon, photographed by W. J. Stillman in 1869.*

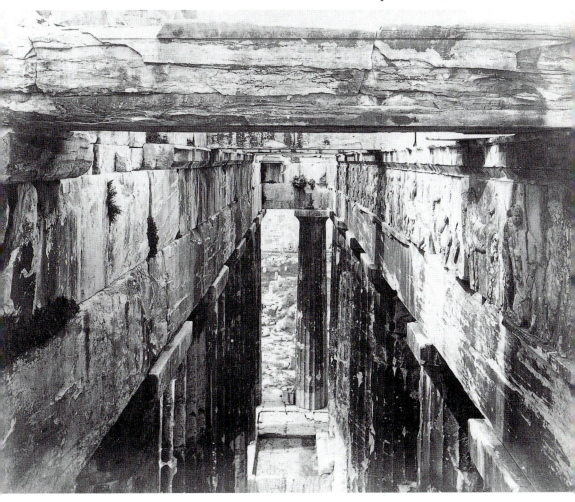

Fig 13 *A Doric capital from the facade of the Propylaia to the Athenian Acropolis, brought from Greece by Lord Elgin and now in the British Museum.*

sion throughout is of great care, and great expense, though it would appear that in antiquity the fame of the building rested more on its sculpture (including the culmination, the groups of over-life-size statues in the pediments) than the architecture itself; the expense and lavishness of the work, more than the actual design.

The finished building, like all temples, was painted; colour washes picked out important elements of the architecture (certainly, for example, the continuous band at the top of the architrave, the projecting regulae and the triglyphs). There were also more delicately painted patterns on the mouldings, and though these have faded they have left their traces, on the building itself, and on blocks which are now in museums; they can be seen also in the great, unique gateway building to the acropolis, the Propylaia, built immediately after the Parthenon (though its design was curtailed as an economy on the approach of war), whose architecture and proportions echo those of the great temple to which it gave access.

Ionic temples

Despite the expense and the magnificence of the Parthenon, it was by no means the largest of Greek temples. These were to be found in the East Greek area, and are in the Ionic order. The early development of

Ionic is difficult to trace, and there is far less consistency, even allowing for regional variation, than in Doric. The earliest known Ionic building is the so-called House of the Naxians in the sanctuary of Apollo on the island of Delos, probably, but not certainly, his first temple there. It is not like the temples described above. Originally it consisted of a plain rectangular room, with an inner colonnade of tall, slender columns in marble supporting the ridge. Naxos, a nearby major island, seems to have dominated Delos at this time. It has abundant marble, almost as good in quality as that on the neighbouring island of Paros, and the quarrying and working of this, particularly for sculpture, developed early on. Over-life-size statues were carved in huge single blocks, already roughed to shape in the quarry itself, and by the House of the Naxians stood the largest of them (only fragments survive), which must have been about 9 m tall. The inspiration – and the necessary technology – must have come from Egypt.

Fig 14 The 'oikos of the Naxians', Delos (in the left foreground), probably built as a temple of Apollo. Behind is the stoa of the Naxians.

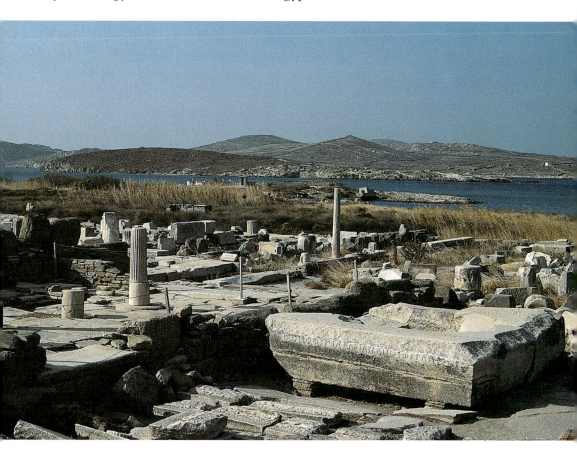

The major Ionic temples, however, are further to the east, that of Hera on the island of Samos, of Artemis at Ephesos (Diana of the Ephesians), and Apollo at Didyma in the territory of Miletos.

The architectural remains on Samos are scanty, but give clear evidence for a sequence of peripteral temples, going back to the earliest emergence of the temple form in the eighth and seventh centuries BC, when the columns and entablatures were still of wood (no trace has been left of whether or not they were already recognisably Ionic) and the walls of mudbrick. The published plans of these early buildings are to a certain extent restorations, but they show essential characteristics, a distinctly long, narrow form to the cella, and, certainly by the seventh century, the relatively deep porch (here restricted to one end) which was to become a regular feature of Ionic in contrast to Doric buildings. These were replaced by a colossal marble structure, definitely Ionic, dated to *c.*570 BC, echoes of which − at least the name of the architect − remained to be recorded by Vitruvius. The dimensions did not result merely from a scaling up of the earlier temples. The cella, of course, was wider and larger, to create the core of the structure, but the overall dimensions were enlarged still more by doubling the external colonnade, now of marble, to give the effect of a forest of columns. Again, it is sensible to look to Egypt for the inspiration for this, to the temples with their multi-columned 'hypostyle halls'. But the temple at Samos was not in any way an Egyptian building; the concept of multiple colonnades was used in a totally different way, and as an extension of the basic Greek form of an inner cella surrounded by external colonnades.

The size of this temple should reflect the same purpose as the (admittedly more modest) size of the Parthenon − devotion to the deity, and the desire for prestige. There seems to have been an element of rivalry, for at about the same time (but almost certainly subsequently) an equally colossal temple was constructed for Artemis at Ephesos. Here again is an archaeological record of earlier structures, but apparently not of conventional temples. The sequence starts with a rectangle of masonry which has been described since its discovery as a base, on which some focus of cult was placed, but which was not in any architectural sense a building. After this came a temple-like structure, large enough but dwarfed by its eventual successor which

Fig 15 *Architectural elements of the later Temple of Artemis, Ephesos: the decorated lower drum of a column.*

was similar in plan to Samos, and of about the same size. This had the deep Ionic porch, and was surrounded by a double row of columns. The temple was destroyed by fire in 356 BC and rebuilt, on the same foundation and essentially to the same plan, with an additional row of columns across the front (though a forerunner to this may already have been added around 395 BC). This stood on a higher platform, and probably had a mainland-type false porch at the back, but in essentials the earlier and later buildings were the same. They were situated, like the temple to Hera on Samos, on lowlying ground – the higher platform of the fourth-century temple was probably made necessary by a rise in the flood level of the nearby river. The earlier temple had some variety in its columns. Some had the bottom drums

of the shaft, immediately above the elaborate Ionic bases, decorated with carved figures, while there are variant capitals with rosettes replacing the spirals of the volutes. One of these figured drums, now in the British Museum, has an inscription saying that it was dedicated to Artemis by King Croesus. Croesus was not Greek, but the ruler of the kingdom of Lydia, next to which Ephesos was situated (and indeed, the cult of Artemis had strong local connotations which presumably antedate the foundation here of a Greek settlement, probably around 1000 BC). Croesus' kingdom was infinitely more powerful and wealthy than a Greek city like Ephesos; indeed, at this time Ephesos was probably subject to him, and his expenditure on the temple is his way of demonstrating to other communities how powerful and wealthy he was.

Fig 16 The British Museum excavations of the Artemision at Ephesos in the late nineteenth century. A steam pump was used to drain the waterlogged site.

There is an architectural problem about this temple, and its fourth-century replacement. The original excavation was carried out, on behalf of the British Museum, in the 1870s by J. T. Wood, with subsequent excavation by D. G. Hogarth. Great difficulty was encountered dealing with a site which was below the modern water table, and steam pumping engines had to be brought in to keep the water down. The temple

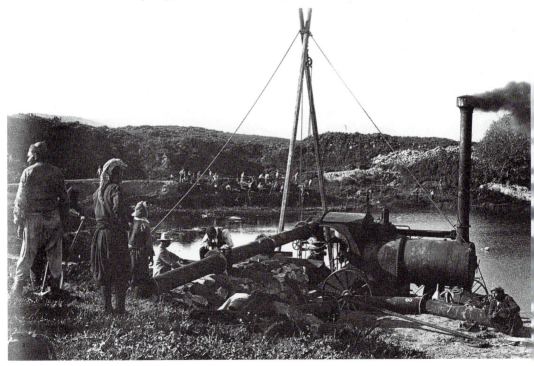

was completely ruined, but parts of the superstructure, both of the final and – most fortunately – the sixth-century version, were found and brought to London. Neither these excavations, nor the more recent ones by the Austrian Archaeological Institute, revealed any trace, not even foundations for the supports, of the roof over the wide span of the cella; at 21 m, well beyond the possibilities of Greek roofing technique. The only conclusion possible is that, most abnormally, the temple was unroofed (perhaps containing a shrine structure which has left no trace, to house the cult image). This was true of its immediate predecessor, and the earlier 'base' must have stood in the open air. It is also true of the temple of Apollo at Didyma, again in its early and later forms. Here, it seems, there was a strong local regional approach to the concept of religious architecture.

The exterior must have been very impressive. The carvings on the columns add to its ornateness. As with other Ionic temples, the spacing of the eight facade columns varied, the greatest width coming between the two central columns. This was no less than 7.6 m, a distance which had to be spanned by single beams (presumably divided into a front architrave with backer, to reduce the colossal weight). On the other hand, there seems no trace of pedimental sculpture (which would have added to the unsupported weight at the centre) and the Ionic order has the conventional East Greek form of a dentil frieze rather than a carved continuous frieze; but the entablature was surmounted by a continuous gutter (not found normally with the roofs of Doric temples, at least in the early period) which in effect formed a vertical parapet, and was given carved decoration on its front. This, the last part of the order to be made, appears to date from long after the beginning of construction, when Ephesos had become part of the Persian empire.

These political factors – Persian occupation, and the subsequent establishment of Athenian control over the Greek cities of the east (they contributed, perforce, to the expenditure on the Athenian temples) – led to a drying up of funds for building in the East Greek area, and there the Ionic order stagnated. However, because the Athenians justified their control by the legend that they were responsible for the founding of the East Greek cities, and because they had become the enemies of the Dorian Spartans, it was decided to build Ionic temples

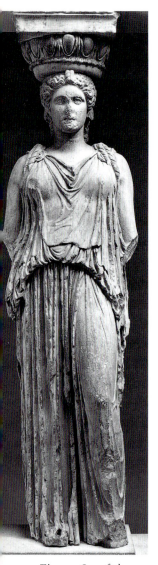

even in mainland Athens – the little Temple of Victory at the entrance to the Acropolis, the largely lost temple by the River Ilissus (drawn in the 1760s, by Stuart and Revett, when it still survived) and, most splendid, the so-called 'Erechtheion', actually a replacement for the traditional temple of Athena, a Doric building destroyed by the Persians. In plan, to incorporate a variety of sacred spots within an architectural embellishment, the Erechtheion is totally anomalous, and, like the comparable Propylaia, illustrates the difficulties Greek architects experienced when designing anything more complex than the traditional simple rectangular temple box. Its details are exquisite, with finely carved mouldings and ornate capitals. Moreover, the main structure replaces the dentil frieze with a continuous frieze, in black Eleusinian limestone, contrasting with the marble of the remainder of the structure, and particularly the carved white marble figures which were pegged to it, in place of the normal relief work. These temples have simpler bases for their columns than those of the East Greek temples – 'Attic', rather than 'Asiatic' – and these set a pattern which subsequently became general for Ionic and the derived Corinthian order.

Fig 17 *One of the 'maidens' from the south porch of the Erechtheion, Athens.*

CHAPTER 3

Greek Cities:
Houses, Theatres and Halls

H istorically, the Greeks began to develop cities from the eighth century BC onwards, though this refers more to political than architectural organisation. The process varied considerably from region to region. Archaeologically, it is difficult to elucidate the transformation from habitation in small villages (which in any case continued, to a greater or lesser extent, throughout the classical period) to the formation of urban communities: the successful cities – such as Athens – were continuously inhabited, and only small sections have been excavated down to these early levels. Clearly, the traditional cities were the result of natural development, centred perhaps round a defendable citadel, such as the Acropolis at Athens, and with immediate access to good water supplies. Such a town became an irregular cluster of houses with an unplanned network of streets, their line determined by the lie of the land and local needs for communication. Planned communities came into being with the establish-

Fig 18 *The acropolis at Athens from the south east, an 1869 photograph by W. J. Stillman. In the right-hand middle ground is the Hellenistic Corinthian temple of Olympian Zeus.*

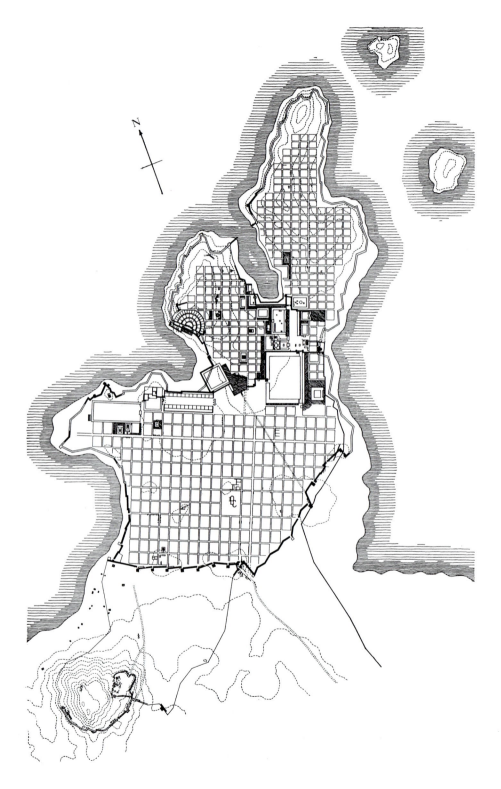

ment of colonies away from mainland and Aegean Greece, where the allotted land was laid out in regular sized plots, made possible by the division of the area for the new community by a regular grid of streets. Such plans are found, for instance, in the Greek cities of Sicily (such as Himera) in the course of the seventh century BC. This developed into a firm concept of planned communities, and these came to be created, where there were special needs, even in the 'old' Greek areas. The new harbour town of Piraeus was laid out for the Athenians, perhaps in the 460s, by the most famous of ancient town planners Hippodamos of Miletos (whose native city, destroyed by the Persians in 494, had been recreated to a grid plan after 479).

Within these cities, areas were set aside for various aspects of the community's existence, besides the private houses of the inhabitants. The architectural development of public buildings, outside the temples and sanctuaries, was slow. Much activity, such as political meetings and administration, legal business, athletic and artistic contests, which were the essence of Greek community life, in the Greek climate could take place normally in the open air, and no buildings were required for them. Thus an early Greek city would comprise, architecturally, a sanctuary with temple buildings, perhaps fortifications for a citadel (which could well be an inheritance from the Late Bronze Age) and the houses straggling round it. In terms of construction, therefore, the private houses are at first the main element in the cities outside the temples.

Fig 19 Opposite *Plan of the city of Miletos, a restoration which is partly conjectural and partly based on excavations and surface indications.*

Greek houses

Few early houses have been excavated. There is evidence for simple huts in Dark Age Athens. The rather remote town at Emporio on the island of Chios, which never developed its urban arrangements beyond the seventh century BC, has produced a large number of simple rectangular houses, a minority of which have the 'megaron' arrangement with a porched entrance at one end. Probably the most significant collection of early houses, of a slightly more sophisticated nature, is found at a small settlement to the south side of Mount Hymettos, in the territory of Athens, whose modern name is Lathouresa. Here the houses consist of an assemblage of irregular but curvilinear rooms,

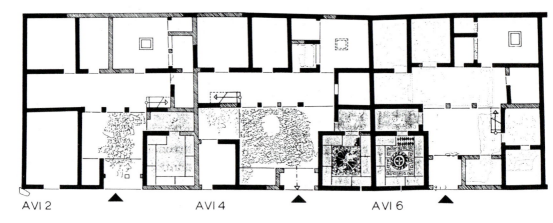

AVI 2 AVI 4 AVI 6

Fig 20 *Houses from the early fourth century* BC *at Olynthos. Each has, to one or other side of the entrance, a formal dining room (andron) with couches and, in two, a mosaic floor.*

each rather like an individual but formless hut, grouped round an open space. With these we have, in the eighth century BC, the beginnings of the principle which comes to dominate Greek home arrangement, rooms opening off an enclosed, internal courtyard. By the sixth century BC perfectly regular courtyard houses are found in the Sicilian Greek city of Himera and there are many more examples of the fifth century BC. Certain characteristics are normal. The entrance is not on any central axis, but to one side, and generally indirect, so that when the front door was open no direct view was possible from outside to the interior of the house. The courtyard is generally without columns (though literature tells us that already in fifth-century Athens the houses of the wealthy may have had stone colonnades round their courtyards). One side, however (generally that on the north) has a verandah, which may have required one or two wooden posts to support it. The principal room is behind this. Other rooms, opening into the court, and lit from it, rather than through windows from outside, had variable functions. Some can be recognised as kitchens, others were formal dining rooms where guests – male – would feast reclining on couches placed round the wall, head to foot (such rooms are recognisable by the low plinths for the couches by the wall, and an off-centre door corresponding to a vacant couch place). Many houses must have had upper storeys, and staircases leading to them, though upper rooms may have been restricted to one side only (again, presumably the north) with access to the rooms by an upper verandah over the lower. Such houses were well suited to the hot climate of Greece, but gave reasonable protection during the occasional cold spells of the winter. More

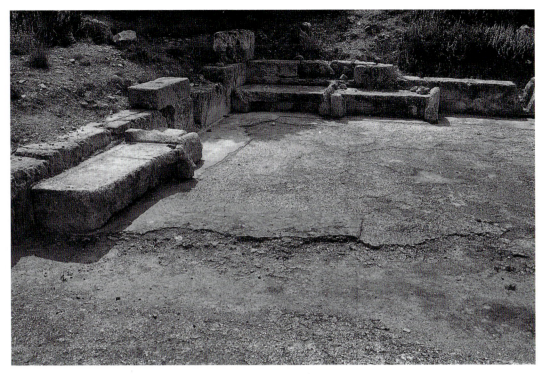

particularly, they suited the Greek desire for privacy in domestic life, and in particular the seclusion within the house of women. This concept, the desirability of being enclosed within a building, was to become important.

Stoas

The first category of public building to develop after the temples was the stoa, a portico designed to provide shade and shelter within or against a public open space. The earliest example known is in fact in a sanctuary, that of Hera of Samos, and was constructed in the seventh century BC; from it worshippers could observe ritual performances in the open space in front. Architecturally it was very simple – a long rectangular building, with a back wall, turning at either end, and two rows of wooden posts, one internal supporting the ridge, one external forming the facade. It is likely that similar stoas were created around secular public open spaces, outside the sanctuaries, particularly at the agora, the gathering place where the citizens came together for community matters; none, however, is known until the turn of the

Fig 21 *Formal dining room* (hestiatorion) *at Perachora. Here the couches – which would have been given real mattresses! – are of stone rather than the usual wooden furniture used, for example, in the houses at Olynthos.*

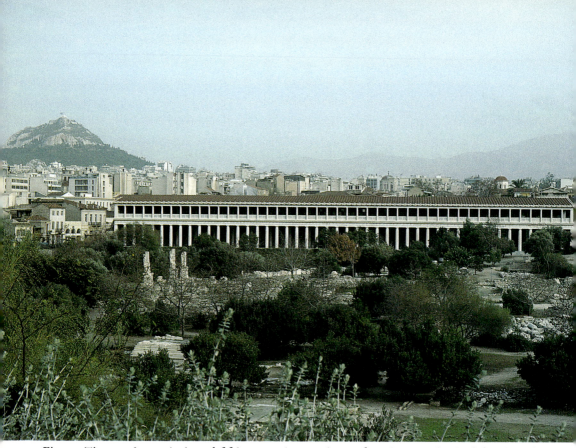

Fig 22 *The stoa of Attalos II closing the east side of the agora at Athens. It has been rebuilt, using much new material, to house the Agora Museum. Behind, to the right, is the 'Tower of the Winds' (see fig. 35).*

sixth and fifth centuries BC, long after the temples had developed their more complex architectural structure. The logical development was to use the concept of the stone colonnade found in the temples for stoa buildings. These occurred, increasingly, in Athens, where some important examples were placed around the agora. Even if they borrowed architectural concepts from the temples, they were generally modified with a view to economy. The stoas of the Athenian agora, from the early 'Stoa of the King' to the later, fifth-century South Stoa, have Doric columns, but of limestone not marble, and spaced more widely (and so more economically) than in the temples. In the Athenian examples the function of the stoas varied, and they clearly became a useful general-purpose building. All, of course, basically provided shelter. The Stoa of the King was a law court. The Painted Stoa housed on its walls famous paintings commemorating the victory at Marathon. The Stoa of Zeus framed a shrine and a statue of the god; this was the most temple-like of the stoas, having projecting wings at either end (the whole over a three-stepped base – the others had single steps) with closer spaced columns on the wing facades, with marble metopes in the frieze and pediments surmounted by statues, all this echoing

the temple of Hephaistos which stood on the low hill immediately behind. The South Stoa (which, like the Stoa of Zeus, had an inner colonnade of Ionic columns, at double the spacing of the external Doric) fronted a line of rooms, whose off-centre doors and plinths around the wall show that they housed couches, for the official feasting which was one of the functions of city political life, and which is mentioned in the context of the agora by the comic playwright Aristophanes. This stoa was certainly built cheaply. A single step fronts a floor of beaten earth, quite unlike the stone paved floors of the temples, while the walls were largely of unbaked mudbrick. Quite apart from their individual functions as buildings, collectively these stoas had another important architectural effect. They were all placed around the edge of the agora, facing inwards. Though there were spaces between them (and the arrangements along the east side were different) they effectively turned the agora into a courtyard space enclosed within the surrounding colonnades, in a way which – on a much broader scale – echoes the enclosed courtyards of contemporary houses.

Until the end of the fourth century there was little development in stoa form. They remained single-storeyed and generally simple in plan, as straightforward long rectangles; the type with wings such as the Athenian Stoa of Zeus is not repeated until later in the fourth century BC when an altogether colossal stoa, the Stoa of Philip, 155.5 metres long with two internal rows of columns as well as the facade, was built along the agora at the planned city of Megalopolis in Arcadia. Here the reason for the shallow projecting wings was presumably aesthetic, to provide discernible terminations to what might otherwise have appeared to be a never-ending line of columns. Some other stoas emphasised their role as boundary closures by turning corners to form an L-shape plan. There is an early example, the Stoa of the Naxians, in the sanctuary of Apollo on Delos, of the late seventh or sixth century BC, and another in the agora at Argos, of the fifth century. Even so, during the fifth and fourth centuries stoas in agoras generally remained separate buildings placed on the edge, rather than total enclosures. The concept of total enclosure, on the other hand, is found already at the end of the fifth century, at the Pompeion in Athens, the place where the Pompe, the sacred procession, gathered before making its way from the western edge of the city through the agora and up onto

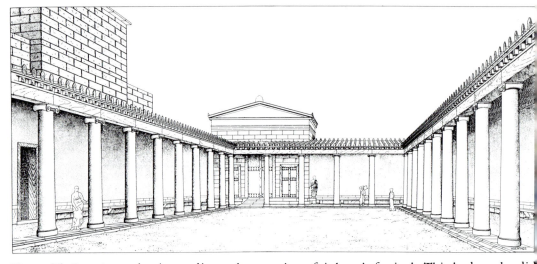

Fig 23 *The Pompeion (restored), the assembly point for the* Pompe, *that is, the sacred procession of the Panathenaic festival of Athens.*

the Acropolis on the occasion of Athena's festival. This had a splendid formal gateway, with Ionic columns and triple doors (the threshold of the main centre door marked with ruts from the wheels of the chariots and wagons which were part of the procession). Inside, the courtyard was totally enclosed by surrounding colonnades, of very plain Ionic columns with simple unmoulded disc bases and capitals where the volutes were only blocked out. Apart from the gateway building, walls were of unbaked mudbrick and the entablatures of timber. Entered from this courtyard was a whole series of dining rooms, holding seven, eleven or fifteen couches, with floors of pebbles set in cement, a normal practice with these rooms making it easy to wash them down after the feasting.

Other public buildings

Also largely a development of the classical period are buildings and rooms designed to hold larger numbers of people for political or religious (or religion-related) activities. These demonstrate the technical limitation of Greek architecture. A reform of the Athenian system of government at the end of the sixth century created a council of 500 citizens, whose main function was to deliberate, in private, business to be presented to the assembly of all the citizens. To maintain privacy, it had to meet in a closed building; the problem was to build one which could hold 500 and still be roofed by the simple beam and support system, with its limitations of beam length. Two attempts

were made. The first building was square, with probably a pyramidal roof rising to a point from all four sides, supported on rafters which rested on an inner square of four piers. The arrangement of the seating is not absolutely certain – probably in straight lines along three sides of the square. However it was done the piers would have obstructed the line of vision for some. This was replaced towards the end of the fifth century by a rectangular structure containing a lobby in front of the seating, and the required points of support arranged on the wall separating the auditorium from the lobby, and towards the back, where they did not obstruct the seating. Even so, this required beams between the supports of nearly the maximum available length. The exact plan of the seating is uncertain, as are the details of the super-structure, but the roof was probably ridged, with gables at each end, and perhaps with windows high up in the walls; if so, this set a type which was to be developed abundantly in the succeeding Hellenistic period. More spectacular was an assembly building at Megalopolis, behind the Stoa of Philip, apparently designed to hold the much larger council (probably 5000) of the Arcadian Federal League. This is near square, 67.71 × 86.10 m, and, with its roof supported by traditional

Fig 24 The Telesterion, the enclosed hall for the performance of the secret 'mysteries' of Demeter at Eleusis.

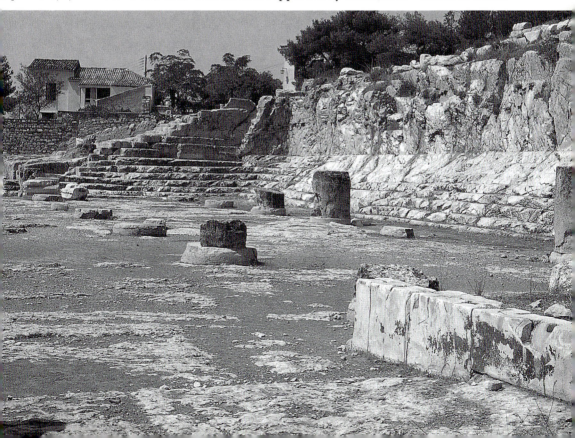

post and beam methods, required a veritable forest of columns. These however, were arranged in lines radiating from the central focus (presumably the point from which the council was addressed) giving easy vision between them even from the back. This is a more advanced system than was used for the large Athenian closed halls – the Odeion of Perikles, attached to the sanctuary of Dionysos on the south side of the Acropolis, in which choral odes were performed as part of the religious festival; and the Telesterion at Eleusis, the building in which initiates saw the performance of the mystery ritual of Demeter and her daughter Kore. Both required a large number of internal supports but these were arranged simply in lines across the width of the buildings, without any thought to restrictions of visibility. An attempt was made to improve the Telesterion by giving the columns an extra wide spacing, but this was abandoned as impractical, presumably because of a dearth of suitably large timbers, when only a few of the foundation for these supports had been put in position.

More usually, the dramatic and athletic contests which were an essential part of Greek religious practice would attract larger number – in theory, the entire community, at least in a local sense. There was no possibility of creating covered buildings for such large numbers and given that the festivals mostly took place at times (allowing for the vagaries of the Ancient Greek calendar systems) when the weather would be fine, it is quite clear that for a long time these activities did not require any architectural arrangement at all; a suitable piece of land with a sloping bank for spectators was adequate. With growing numbers, and, in special circumstances, the development of the performances into something more sophisticated (particularly the drama at Athens), more complex arrangements were necessary. This led to the creation of the theatre and the stadium as distinctive elements within the architecture of Greek cities and sanctuaries. Neither amounted to much more than the adaptation of the natural terrace the slopes on which the spectators sat were improved, and facilities created for the performers.

The Theatre of Dionysos at Athens was at the forefront, but the elucidation of its architectural development is fraught with difficulties since the early structure is overlaid with later building, and the decipherment of the fragments (and thus chronology) is not certain

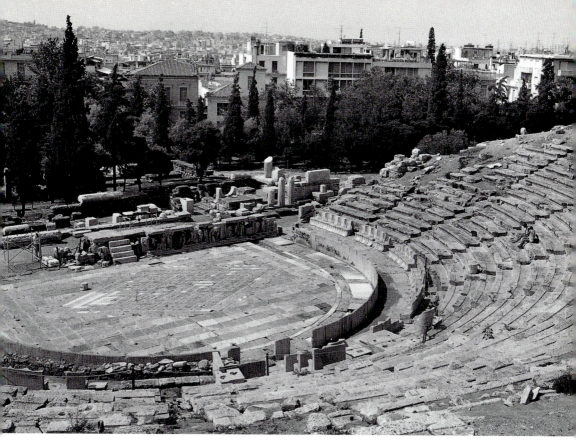

One improvement definitely carried out by the fifth century, since there are literary references to it, was the creation of regular wooden seating, probably in straight sections to give a polygonal (or part-polygonal) form to the auditorium. The place for the actors was separated from the circular dancing floor for the chorus (out of which the drama itself had developed); there also seems to have been provision at the Theatre of Dionysos for some form of conventional setting, at least a door through which actors could appear or disappear (serving, variously, as the Palace of Agamemnon or even the Cave of Polyphemus), and for the equipment – quite ill-understood – which could produce the *deus ex machina*, the 'god from the machine', to bring convoluted plots to a rapid conclusion. This theatre's layout was transformed, at least by the mid-fourth century (or very shortly after), when the auditorium was converted to permanent curvilinear seating in stone (which still survives) and there were probable (but less certain) improvements to the stage building: projecting wings (paraskenia), like the Stoa of Zeus, and embellishment to give the building the appearance of a free-standing colonnade. A recent study convincingly argues that this colonnade effect was in fact created from Doric half

Fig 25 *The theatre of Dionysos, Athens, with the orchestra in its Roman form, and the ruins of the stage buildings including the late Roman stage.*

columns engaged against the wall, an important new architectural concept, though one derived, of course, from the architecture of the temples.

Other structures with temple-derived colonnades were the fountain houses, where a porch-like building, over the managed source (in the form of spouts flowing into catch basins), provided shade and coolness both to the water and those collecting it; there were examples as early as the sixth century BC in Athens. Increasingly in the fourth century commemorative monuments assume an architectural form – decorated bases for statues, especially outdoor examples, lions commemorating battles such as Chaironeia, or monuments set up to honour victory in the dramatic festivals of Athens, such as that of Lysikrates on the 'Street of the Tripods' at Athens. Monumental tombs of architectural complexity were somehow alien to the Greek attitude, but they were built, using or adapting the temple architectural forms, for non-Greek dynasts. Tombs of this kind were erected in Lycia (southern Turkey) but the most spectacular was the Ionic Mausoleum, the tomb of Mausolus, dynast of Caria, who made his capital at the Greek city of Halicarnassos, and employed Greek architects (Satyros and Pytheos

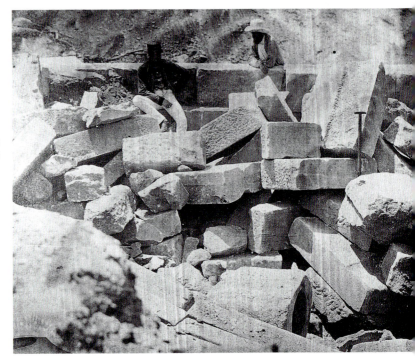

Fig 26 *Excavation of the Mausoleum, Halikarnassos, photographed by Corporal Benjamin Spackman of the Royal Engineers, during the excavation by Charles Newton in 1856. The blocks are steps from the pyramid-form roof. The two figures are Lieutenant Murdoch Smith (left) and Charles Newton.*

o build his tomb, and Greek sculptors to adorn it. Perhaps influenced
by this, the kings of Macedon, particularly Philip II, who made himself
master of mainland Greece, devised, as a development of a traditional
Macedonian type of burial, chambers concealed in the ground and
under mounds which make use of the barrel vault. This revolutionary
architectural concept had been dimly foreshadowed in Late Pharaonic
Egypt, but was surely worked out as an architectural principle by
Macedonian architects. These tombs are also important for their decor-
ated (but buried) facades, often, as on the tomb of Philip himself,
embellished with engaged half columns, and, most importantly,
because they were buried still having their painted decoration unfaded.
Having invented the vault, it is strange that Greek architects made
little use of it. It remained for the Romans to do this. The problem
was to relate the curved line of the vault to the angular forms of the
Greek orders; this was possible, in the Macedonian tombs, by adding
the facades as screens in front of the vaulting, which, from the outside,
denied its existence. Perhaps the Greek architects were suspicious of
the stability of vaults (and used them when they were supported by
the pits of the buried tombs or in the thickness of fortifications). It
was left to the Romans to bring them into the open, framed by engaged
half columns and an engaged entablature, in their arcaded structures.

The Hellenistic World

I n 334 BC Alexander, son of the murdered Philip II, king of the Macedonians, set off on the great campaign against the Persian empire which had been planned by his father. By 323 when aged only 38, he died at Babylon, he had removed the dynasty of Persian kings, and converted the whole of the Near East, up to the Indus Valley and including Egypt, into an empire ruled by himself. On his death his Macedonian generals fought and quarrelled with each other over the empire, and after around twenty years of struggle it was permanently divided. Egypt became an independent kingdom but ruled by the Macedonian dynasty of the Ptolemies: Asia, for the most part, was ruled by the dynasty of Seleukos. Macedon remained an independent kingdom, after some vicissitudes, ruled by Antigonos Gonatas and his descendants. There were lesser kingdoms in Anatolia, the most important for the history of architecture being that which was built up, from the middle of the third century, at Pergamon by the descendants of Attalos.

Macedon and the Greek mainland

The architecture of Macedon was firmly rooted in the styles of mainland Greece; it owed much to progressive rulers, Archelaos in the late fifth century, and Philip in the fourth, whose capital, Pella, was transformed into one of the largest and most spaciously laid out of Greek cities, on a grid plan with ordinary streets 6 m wide, and main streets of 14 m, all with regular drainage systems. The blocks of the grid plan measure 110 × 48 m, and at least in the area which has been fully excavated, these were allocated to single-storey courtyard houses of a scale altogether vaster than those of normal Greek cities; where the well-built and comfortable houses of Olynthos were allocated plots about 15 × 15 m, at Pella they were nearly 50 × 50, eleven times as large. Their principal rooms have splendid mosaic floors, with geo-

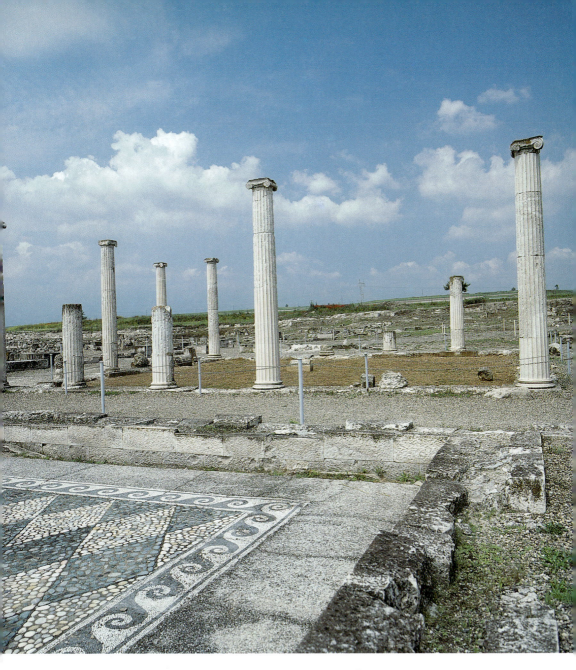

metric patterns and large figure scenes. The courtyards have full peri-styles of stone columns; the walls, though largely fallen, would have been splendidly stuccoed and painted. At the centre of the city-plan is the agora, 180 m square and, at least by the end of the third century, totally enclosed by a continuous double stoa. To this leads the main broad street. Above the town, on its low acropolis, was the Palace of the Kings, where Philip and Alexander lived, thoroughly ruined but clearly on a magnificent scale, forming a double courtyard.

Fig 27 *Spacious late fourth-century BC houses at Pella, the 'capital' of Macedonia (partly restored). There is a colonnaded courtyard in the background, and in the foreground a spacious reception room with a pebble mosaic floor.*

All this results from the rising wealth of Macedon, with its gold and silver mines, but it anticipates the general increase in wealth that was released and stimulated by Alexander's conquests.

This wealth is in general reflected in the architecture of the new 'Hellenistic' world. The old Greek mainland, with its established cities, Athens, Corinth, Argos, and so on, became something of a backwater; Macedon was the poorest of the kingdoms of Alexander's successors. However some technical innovation was to be found in the area ruled by one of the successors, Demetrios, who was at one stage reduced to a petty kingdom in Greece, based on Corinth and cities in

Fig 28 *The theatre at Sikyon with vaulted entrance passages to the higher levels of the auditorium. This is Macedonian work, executed when Sikyon was refounded by Demetrios Poliorketes at the turn of the fourth and third centuries* BC.

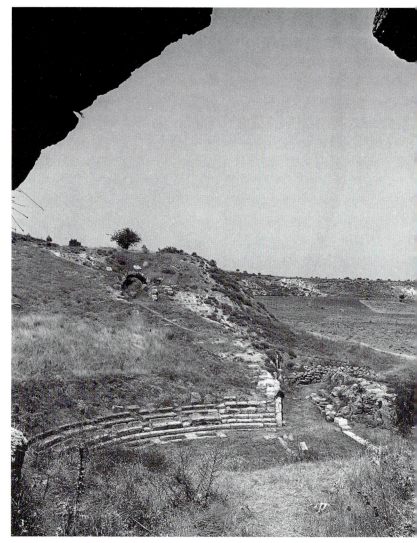

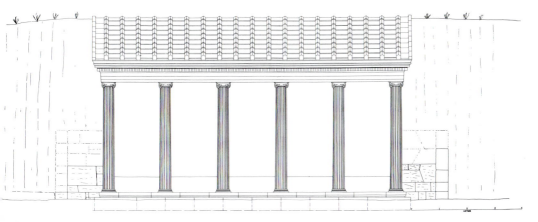

the vicinity. One of them, Sikyon, he refounded on a new site; its buildings included a great stadium, following the stadium built at Nemea a few years earlier, and an elegant theatre. Both these stadia made use of the Macedonian development of the vault, with vaulted passages leading into the running course and the auditorium respectively; there were also vaulted passages, again probably the result of Macedonian influence, in the stadia at Olympia and Epidauros. Another interesting development is to be seen at the sanctuary of Hera at Perachora, at the end of the promontory facing Corinth, where Demetrios (probably) constructed a waterworks system of deep shafts, through which water was raised by machinery and fed into an elaborate storage cistern with a fountain-house-type facade; the draw basins were shaded by a roof supported by six Ionic columns, of a variant type found earlier in the Peloponnese, and used also for the circular memorial building built for Philip at Olympia, the Philippeion.

Fig 29 The fountain house at Perachora, probably the work of Demetrios Poliorketes. The columns are examples of the Peloponnesian form of Ionic, with four rather than two volutes.

Miletos

The real Hellenistic architectural impetus was elsewhere. The conquest of the East led to the development of new trade routes through and around Asia Minor (the Greek West was in decline at this time), and it was the cities of Asia Minor which revived out of their fourth-century torpor, and flourished. Miletos at last began to develop the civic buildings at the centre of its grid plan, markets and an agora, all dominated by colonnades; in the great South Agora these were not yet continuous (two L-shaped and a single line on the east side) but the

gaps between them were insignificant compared with their great
length, and by the late Hellenistic period had been closed. Although
Miletos was one of the leading Ionian cities, the stoas were given Doric
columns, and this became the general rule. It may reflect the earlier
development of the stoa in Athens as an essentially Doric type of
structure, but more realistically, Doric columns, with their simple
(and now much smaller) capitals, were far cheaper to make than Ionic,
particularly now that their proportions had become as slender as those
of Ionic columns. Even though they were permitted wider spacing
than other colonnades, stoas some 200 m in length, like those of the
South Agora, required a very large number of columns.

Fig 30 *Remains of the
fourth-century Doric
stoa by the harbour at
Miletos, with a
heart-shaped column
used to turn the corner.
The site is now
waterlogged because of
the silting of the
Maeander Valley.*

Two individual Milesian buildings are of particular importance. The
oracular temple of Apollo at Didyma, just to the south of Miletos,
had been destroyed by the Persians in 494 BC, and its hereditary
priests, the Branchidai, banished to a remote part of the empire.
Nevertheless the cult had continued, and at some point in the fourth
century, possibly before the conquests of Alexander, a decision was
taken to rebuild the temple on an even more colossal scale. There is no

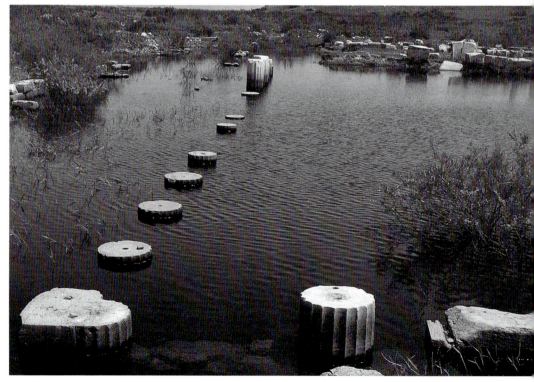

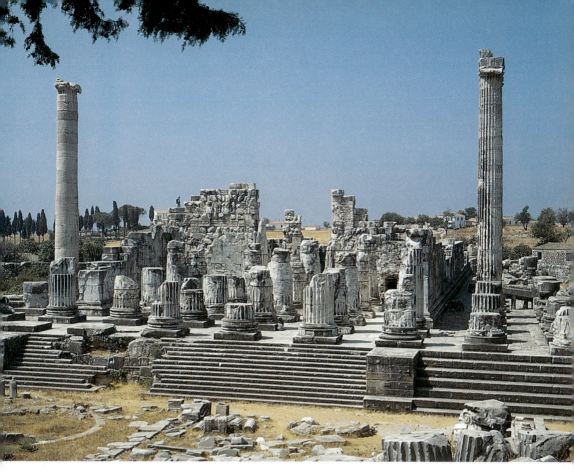

doubt that the changed political – and above all economic – situation of the early Hellenistic period stimulated its redevelopment. The new temple continued the traditional Ionic order, with the Asiatic form of base, though those of the facade were given special decoration. This was the largest of Greek temples, measuring 51.13 × 109.34 m, and having, uniquely for Greek buildings, a ten-column facade. The side colonnades of course were doubled. The internal plan was anomalous; a large unroofed cella whose floor was at ground level, below the platform level on which the external columns stood (it may have been planted with a sacred grove). Between the cella and deep Ionic porch was a roofed room, behind the great front door whose threshold was an inaccessible 1.5 m above the porch floor. Small doors to either side led to vaulted corridors which went down to cella level, where a magnificent flight of steps provided access, via a facade of Corinthian columns, to the front room. Staircases led up to its roof level. Inside the cella was a small shrine building to contain the cult image, presumably that taken to Persepolis in 494 by the Persian king, and restored to Didyma by Seleukos. It used to be thought that this inner shrine

Fig 31 *East front of the Temple of Apollo at Didyma, near Miletos. The steps are doubled at the centre to facilitate access.*

was a preliminary to the redevelopment, but recently an engraving at full scale, of its architectural details, together with a template engraving for the great external columns, has been observed on the inner side of the cella walls, demonstrating that they were already in place when the shrine was built. This means that the temple probably and deliberately echoes the arrangement of Ephesos, and supports the theory that there too the cella had no roof.

The other important Hellenistic building at Miletos is the Council House next to the South Agora, the gift to the city of the Seleukid King Antiochos IV, in about 174 BC. This is a much larger version of the later Council House at Athens; a tall, rectangular building with a ridged roof and gables. Windows were set high in the walls, which were embellished externally by engaged Doric half columns, an interesting development of this idea from its tentative use in the theatre at Athens and, presumably, elsewhere, though the Milesian instance is on a particularly large scale. Inside, seats were arranged to a curvilinear plan, the supports for the woodwork of the roof pushed as far as possible to the side. Despite the vast space to be spanned timbers seem to have been arranged still on the primitive system used in classical buildings. Special timbers must have been selected, but they proved inadequate and the roof eventually collapsed. (There was one Hellenistic building, the palace at Vergina in Macedon, roofed with even wider spans – over 16 m – apparently successfully, which may reflect the special quality of the timbers available there).

Priene

The best-known and most thoroughly explored of the revived Ionian cities is Priene, often used as an example of a typical Greek city, but in fact demonstrating a quality of building and arrangement on a far more solid and expensive scale than would be usual in classical places. It was moved to a new site (or perhaps coalesced out of smaller villages) probably in the time of Alexander, who 'dedicated' the principal temple, that of Athena (designed by Pytheos, one of the architects of the Mausoleum). The town, of course, had a grid plan, with the agora at its centre occupying two blocks of the plan, completely rectangular and edged – in the course of the third century, it would seem – with

stoas open only at the north-east and west corners. There is a well-preserved theatre with an interesting stage building, the stage high and coming over an engaged Doric colonnade. Most interesting are the general amenities: drains, as at Pella, and a water supply brought in a conduit from springs some distance outside the city, and distributed via a system of pipes throughout the town. The houses, too, are solidly built. They lack the magnificent scale of the Pella houses – some indeed are very small – but have well-built walls, many of which, at least for their footings, use a style of masonry prevalent at adjacent cities (such as Miletos), where the faces of the blocks are curved in profile (pulvinated) with sharp bevels at the vertical joints.

Alexandria

Priene may have had a population of five or six thousand, typical of many Greek cities. In contrast are the new great Hellenistic cities, particularly those developed in the non-Greek areas conquered by Alexander, which became the capitals of the successor kingdoms. The chief

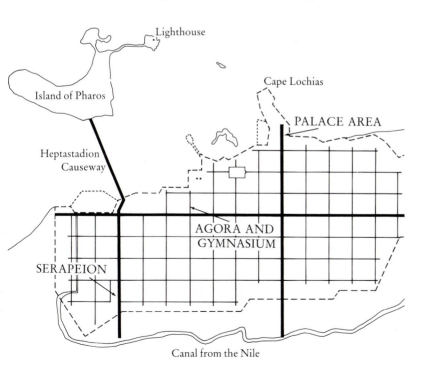

Fig 32 *Street plan of Alexandria showing the prinicpal streets only. Each block would have been divided by cross streets such as that seen in fig. 62.*

Fig 33 *The Temple of Athena at Priene. The columns are re-erected.*

of these were Alexandria in (or, by strict definition, 'next to') Egypt, the capital of the Ptolemies, and Antioch in Syria, the chief town of the Seleukids. Both flourished beyond the Hellenistic period. Both suffered subsequent damage, Antioch particularly as the result of earthquakes, and both are most imperfectly preserved and known.

Alexandria was vast. It covered an area 2 × 5 km, and by the end of the Hellenistic period (and that after years of probable decline) had a population which has been calculated, on the basis of actual figures given by the geographer Strabo, as around one million. The street plan is now largely submerged under modern Alexandria. More was visible in the nineteenth century, when it was recorded, but the streets

seen then can now be demonstrated to have been those of the late Roman period, which perhaps only partly preserved the original Hellenistic plan. Alexandria is perhaps best known from earlier descriptions, but recent excavations have helped to elucidate its arrangement. Part of the enclosed area – perhaps as much as a third – was dedicated to the Royal Palace of the Ptolemies, which comprised a series of buildings, residences for the King and formal banqueting halls, as well as the famous museum and library, and the tomb of Alexander the Great (as a founder hero, his body was moved to Alexandria by Ptolemy I from the destined burial place, a Macedonian-type tomb at the oasis of Siwa where the god Amun had recognised Alexander as his son). The rest of the town was divided into five regions. At the centre was the agora and the gymnasium, past or through which ran the main broad street, supposedly (from the descriptions) some 30 m wide, but proved by excavation to be around 14 m, like the main street of Pella. Pella may well have served as the inspiration for this city, in which case it would have been laid out originally in large building plots for sumptuous single-storey houses. But as the population grew, such luxury had to go, and the large individual houses gave way to tenement blocks, probably on the same plots, and with their courtyards transformed into light wells. Remains of these have been found built of good ashlar masonry, but in the Roman period they were gradually replaced by new structures with walls of mortared rubble. These, however, seem to have been built on the foundations or lower floors of their Hellenistic predecessors, whose plans they therefore repeat, and from this it can be seen clearly that when tenement houses were built in Rome, and above all at Ostia, the harbour town of Rome, they took the form of their Alexandrian predecessors.

Pergamon

Even less is known of Antioch, except that it too was laid out, by Seleukos early in the third century, with a street plan on the model of Pella. A better-preserved, and so better-known example of a Hellenistic capital city is Pergamon. Pergamon claimed to be a Greek city, but when the site was visited by Xenophon at the beginning of the fourth century it was merely a citadel, held by the local non-Greek

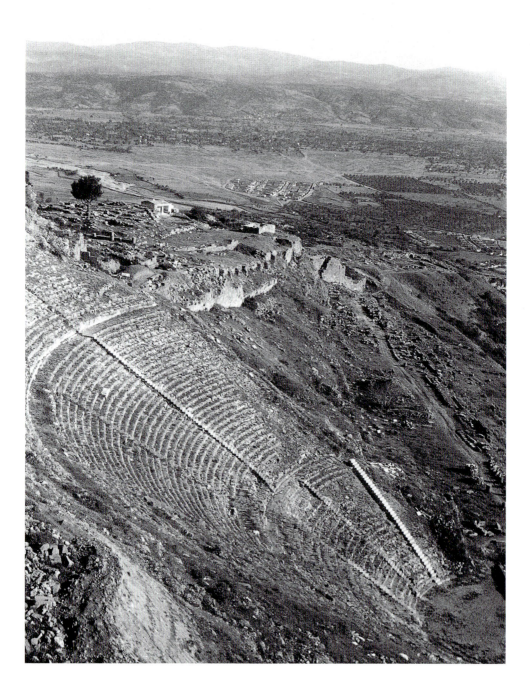

dynast. It continued as a stronghold under Lysimachos, who kept one of his treasuries there under the command of one Philetairos. In the war between Lysimachos and Seleukos, in which Lysimachos was defeated and killed, Philetairos judiciously changed sides, and was rewarded with permanent command of the stronghold. The death shortly after of Seleukos and the help Philetairos rendered to his successor made him virtually independent. After his own death his successors created their own dynasty, eventually taking the title of king to assert their independence.

As their capital, Pergamon was extended downwards from the top of the hill where the garrison post was maintained and where the rulers, the Attalids, had their remarkably modest palaces, which were similar in arrangement to the houses of Pella, and certainly no more magnificent. Below this were sanctuaries, particularly the chief one of Athena Polias (*not* on the top of the hill), an agora, and a splendid theatre. All this was surrounded by a fortification, but later, in the second century when Pergamon reached its zenith, a wall lower down the hill enclosed an even greater area. No regular grid plan could be laid out on this steep-sided hill. Roads zigzagged their way up to reduce the gradient, and the major buildings had to be placed on platforms levelled out of the hillside on major terrace construction to create a sufficient area for them. Pergamene architecture is distinctive. There is no local marble, so any used had to be imported. The local stone is trachyte – hard, darkish material – rather than limestone. For walls, it was often used in thinner slabs than the heavy squared ashlars of classical Greek architecture. These were placed upright, to front and back of the wall, the intervening space filled with clay and rubble. Each pair of upright stones was then capped by a stone placed flat from front to back. This created a distinct pattern to the stonework of alternately high and low courses. It is easily recognisable as Pergamene in buildings constructed elsewhere as the result of gifts from the Pergamon kings in their attempt to win political support (there are examples at Athens, namely the stoa on the east side of the agora, given by Attalos II, and the base for a monument, later re-used by the Roman Agrippa, by the Propylaia at the entrance to the Acropolis). Pergamene architects also developed an alternative form of capital (which had existed in a very few examples in the area near Pergamon

Fig 34 Opposite
View over the theatre at Pergamon. Just beyond its upper levels are the foundations of the Great Altar.

from at least the sixth century) formed from a ring of palm leaves supporting an abacus. It was employed as a simpler alternative to Corinthian, which Pergamene architects did not use.

Architecture at Pergamon was dominated by the need to build on terraces. There were developments in the way the terrace support walls were constructed, leading to a system where the actual wall was strengthened by projecting buttresses, linked at the top by arcades, and all then hidden behind an outer skin of finer stonework. Often the outer skin has fallen, leaving striking views of long arcades; a particularly fine example, visible from some distance as you approach Pergamon from the west, is the terrace below the auditorium of the theatre. This terrace construction was linked to the imaginative development of the stoa form. Two-storey stoas began in Greece with an example at Perachora, where it was made necessary by restrictions of space. Built at the end of the fourth century to an L-shaped plan, the stoa's lower floor has a Doric colonnade, the upper floor an Ionic, a rhythm which becomes normal for later two-storey stoas, such as the Stoa of Attalos already mentioned. Pergamon links the stoa to the terrace wall: outside, against the wall and below the terrace level, are two-storey structures, with shops at the ground level and an enclosed storeroom level above; on the roof of this, facing inwards this time, stands a conventional stoa, with one or two storeys.

Pergamene architecture reveals experimentation and greater flexibility of building form. The details of the classical orders were modified. In general, and particularly in the later Hellenistic period, the second century BC, the strict rules of the conventional classical orders underwent some modification. Already in the fourth century architects working for the Carian dynast, Mausolus, and his successor Idrieus had combined Ionic columns with Doric entablatures. In the Near East and Egypt the Greeks became more aware of non-Greek architectural styles; indeed, the Ptolemies, for political reasons, were enthusiastic builders of temples in the pure Egyptian manner. These Near Eastern forms favoured more ornate types of capital. The Macedonian kings had introduced the severe mainland Doric style into the conquered areas – there are some splendid third- or second-century rock-cut Doric tombs at Alexandria – but it seems (firm evidence, admittedly, is scanty) that this came to be relaxed in favour of more

florid styles, in accordance with local taste, and for this the Greek Corinthian form particularly appealed. Corinthian temples were built at the behest of the Seleukid Antiochos IV in the 170s at Olba in Cilicia, and (a gift) at Athens. With Corinthian come new forms of entablature, especially cornices modified with brackets on the underside (perhaps derived from the Doric mutules). Only a deteriorating political situation and probably a shortage of funds delayed the massive development of these new ideas.

Hellenistic Continuity
under Rome

The Hellenistic world declined in the face of squabbling between the kingdoms, the resurgence of non-Greek powers (particularly Parthia) and, internally, the rebellion of non-Greek populations (particularly Egypt). The Greekness of this area was very much based on the cities, rather than the monarch; in the end, the monarchies were destroyed and the cities rescued by the intervention of Rome, which gradually and after a series of wars converted much (but not all) of the Hellenistic area into provinces, supporting and even extending the city system as a way of life and an adjunct of government. The Roman conquest, therefore, was not so much a revolution as a restoration of the Hellenistic cities, and though the provinces at first suffered from the financial malpractices of Roman governors on the make, the rise of the 'Roman Peace' and the encouragement of trade throughout the Mediterranean led to an enormous economic improvement. More money thus became available for building after a period of some decline. Just as Hellenistic kings had donated building projects as gifts to cities whose support they wanted to cultivate, so the Roman emperors also financed building projects. Athens, which had emerged as a cultural centre, and a place of education for the leading Roman families, was a particular beneficiary of this.

In fact Athens was fortunate. During the decline of the Hellenistic states, and the confusion this caused, Athens had backed the wrong side, at the beginning of the first century BC, in the war between the Romans and King Mithridates of Pontos (a state which had broken away from Seleukid control in the second century BC). Athens was attacked by a Roman army under Sulla, the politician who then dominated Rome, which forced its way into the city at the western gate, the Dipylon, burned the adjacent Pompeion and then caused widespread

damage in the city. Private houses and other buildings were destroyed. Afterwards, the debris was cleared and dumped, and where this has been found by archaeologists it includes fragments of painted wall plaster, showing that the systems of decoration employed were similar to those used at the same time in Pompeii, a clear indication of the links between Roman and Hellenistic architecture.

The architectural revival of Athens was slow. Many buildings were abandoned, including the Pompeion and Philo's great naval arsenal at Piraeus. Reconstruction by the Athenians themselves was sporadic and poor, and it is not until the time of Julius Caesar, some forty years later, that better quality buildings are found. These include an area to the east of the agora, where attempts had been made by the

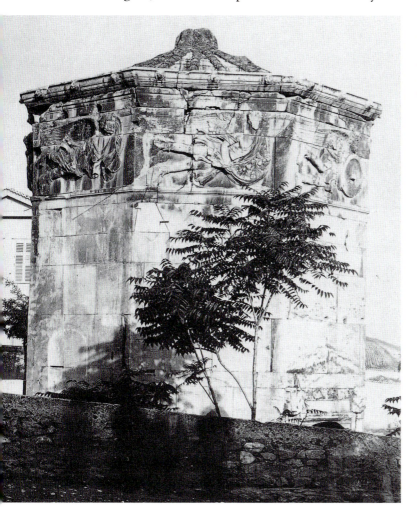

Fig 35 *The 'Tower of the Winds', the* horologion *(water-clock) of Andronikos. The photograph was taken by Félix Bonfils,* c.*1870.*

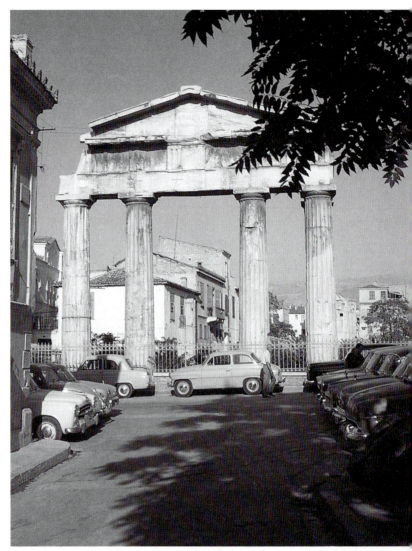

Fig 36 *The Doric propylon to the Roman agora, Athens, first century* BC.

Athenians to create a courtyard building, of uncertain purpose, out of re-used material. This was gradually developed as a commercial market, the 'Roman Agora'. By it is the Horologion of Andronikos of Kyrrhos, the renowned 'Tower of the Winds', an interesting piece of fanciful construction. It is octagonal in plan, each side facing the direction of one of the winds (which in antiquity had individual names such as Boreas for the north wind, not just the compass bearing). At the top of each side is a relief carving depicting the personified wind. A vane and pointer on the top of the roof indicated the appropriate relief according to the direction of the wind. The tower also contained

the reservoirs and mechanism for the water clock (*horologion*) which gave it its real name. Architecturally what is noticeable about this monument, which was probably built some time after the middle of the first century BC, is that it shows distinct Pergamene influence – the alternating high and low coursework of the Pergamene masonry, the use of Pergamene palmleaf-type capitals. Structurally, it is a clear continuation of Pergamene form.

Other buildings are even more conservative. A gateway building to the 'Roman Agora' is in the Doric order, with the proportions of the order's Hellenistic form, though the capitals are more substantial. It is not pure fifth-century, but seems to have been constructed under the influence of the classical buildings visible from its position. One of these, the Erechtheion, suffered severe damage by fire at this time. It was most carefully repaired, the classical details being reconstructed, where necessary, in their original form, and with workmanship which approaches their quality. Even more interestingly, the craftsmen who had developed these skills went on to build a small circular pavilion, dedicated to Rome and Augustus, in the same Ionic style as the Erechtheion itself. There is another magnificent example of this extreme architectural conservatism at the sanctuary of Demeter and Kore at Eleusis, where as late as the second century AD a gateway building was put up which was based on the Propylaia to the Athenian Acropolis, and re-used its fifth-century BC Doric and Ionic details and columns.

Fig 37 *The remains of the Great Propylaia at Eleusis, a second-century AD copy of the Propylaia to the Athenian acropolis.*

Obviously, much of the motivation behind this was an obeisance to the magnificent and admired architecture of the classical period. More generally, in the cities of the Aegean area, the 'old' Greek world with its long architectural traditions, there was a strong element of continuity of style which was not affected by architectural developments at Rome itself, almost denying that there had been any political change. In inland Caria the city of Aphrodisias developed in the late Hellenistic period, and this development continued and flourished when it was part of the Roman empire. There were good sources of white marble in the vicinity, which was used in its buildings. The buildings include the important temple of Aphrodite, peripteral in the Ionic order, its details including a crisp maeander pattern on the lower exterior of the cella wall. In plan this follows the examples of earlier East Greek Ionic temples and, of course, it stands on a stepped base of the type universal in Greek peripteral temples.

Fig 38 *The Temple of Aphrodite, Aphrodisias, with some alterations to the colonnade made during the conversion of the building into a church.*

At the centre of the town, discovered quite recently and not yet systematically published, is the Sebasteion, a complex shrine dedicated in the reign of Nero to the Sebastos – that is to the emperor Augustus in the Greek version of his honorific name. Stoa-like porticoes 80 m long line a paved area 14 m in width which lead at its east end to a temple or shrine which no longer survives. The porticoes have engaged half columns in the Doric order for their lower storey with capitals whose abaci are decorated with carved 'egg' mouldings (as were the external capitals of the Council House at Miletos). The columns stand on simple bases. Above this, the second storey was Ionic; and above this, yet a third storey, in the Corinthian order. The two upper storeys were embellished with relief carvings, in the florid figure style which was essentially derived from that of Hellenistic Pergamon, representing the peoples conquered by the Romans. Here we have a building of the Roman empire which represents a clear continuity of late Hellenistic concepts. The theatre, though modified later, was also originally Hellenistic in its arrangement, its proskenion decorated with engaged Doric half columns reminiscent of the second-century BC stage

Fig 39 *The theatre at Aphrodisias.*

at Priene; yet an inscription shows that it was dedicated by Gaius Julius Zoilos, the freedman – that is, former slave – of the son of the deified Julius who became the emperor Augustus, so this is part of a development which belongs to a time early in the reign of the emperor (in fact, before he took the name Augustus, in 27 BC), and another clear indicator of the continued impact of Hellenistic form.

There are other temples in Asia Minor which reflect this same continuity, to the extent that there was for long confusion as to whether they were actually Roman or Hellenistic. In fact, such terminology is meaningless, and can refer not to the style of the buildings themselves but only to their date. In reality they are buildings of the Roman period designed in Hellenistic style. One example is the temple of Rome and Augustus at Ankyra (Ankara), which in plan and general arrangement resembles the temple of Artemis at Magnesia, the master-piece of the early second-century BC architect Hermogenes, in that it stands on a stepped base and is pseudo-dipteral (that is, though there is room for two rows of columns around the cella, only the outer row was actually built). It was probably Ionic but nothing of the outer colonnade actually survives; the inner porch columns may have been Corinthian. Corinthian, also, is the temple of Hekate at Lagina, and the temple of Zeus at Euromos in Caria – again with a stepped base and a typically deep porch of the form traditional in Ionic temples. Another Ionic example is the temple of Apollo Chresterios, near Aigai, in the hilly country to the south of Pergamon. The list could be extended considerably, and it is clear that where temples were built in Asia Minor in the Roman period they continued to be Hellenistic in form. Podium temples of Roman type are the exception, and generally indicate a specifically Roman context (the temple of Trajan at Pergamon).

Ephesos

During the Roman period, the most important city in Asia Minor and administrative centre of the Roman province of Asia was Ephesos. It is here that the continuity of Hellenistic architectural concepts is most clearly demonstrated. The site of the early city is not known. Roman Ephesos was essentially a continuation of the Hellenistic city,

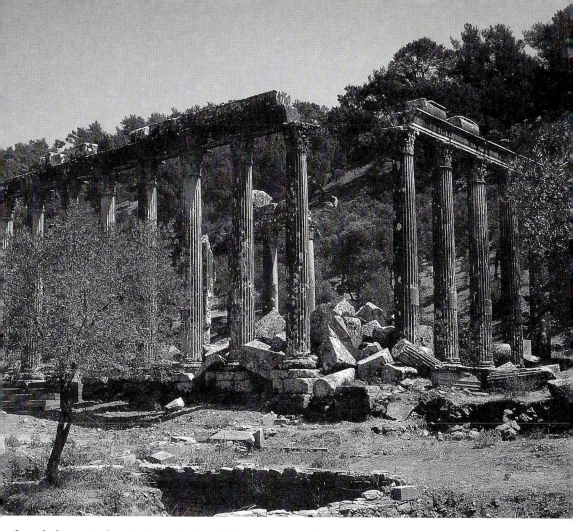

refounded at the beginning of the third century BC by Lysimachos, who gained control of this part of Asia Minor after the battle of Ipsos in 303 BC. He incorporated into his new town a considerable tract of land on the slopes of two hills (now Panayir Dagh and Bulbul Dagh, the ancient Mount Koressos), together with the intervening valley and the flat land below them which ran to the harbour on which Ephesos' prosperity depended. This was surrounded by an up-to-date fortification of rusticated ashlar masonry with frequent rectangular towers designed to house torsion catapults which were by this time a regular part of any defensive system. Within this area, but not extended to cover the whole of it, Lysimachos' town planners laid out a conventional grid plan of streets. Only part of this has been excavated, but the lines of the streets can still be seen as marks in the unexcavated areas. A main street ran along the bottom of the Panayir Dagh, on the main north–south alignment; another road led up at an excep-

Fig 40 *The Corinthian Temple of Zeus at Euromos. Second century AD.*

tional angle to the grid system, through the valley separating the hills to the gate in the city walls at the top of the low pass between them, the Magnesian gate. Another important road, later named Arkadiane after the late Roman emperor Arcadius, ran down directly to the harbour. Around or accessible from these roads are the major buildings.

Little survives from the Hellenistic period, almost certainly as the result of earthquake damage, making a total reconstruction necessary during the first century AD, but many of the reconstructed buildings do have an essentially Hellenistic character. General characteristics are construction in ashlar masonry, rather than mortared rubble or brickwork, either as smoothed blocks or, in substructures and support walls, forms of the pulvinated, curved surfaces so popular in this region in the second century BC; and the use in the buildings themselves of the classical orders Ionic and, for lesser structures, Doric. The great theatre, which dominates the view of Panayir Dagh from the west, almost at the head of the Arcadiane, is an obvious example. It was here that St Paul preached on a visit to Ephesos, and provoked the riot of its citizens who clamoured for Artemis (Diana of the Ephesians), the tutelary deity of the city since its earliest period. From the account of this in the Acts of the Apostles we know that the theatre was under reconstruction at the time, shortly after the middle of the first century AD. The theatre is huge, with three sections of seating, supported at their ends on massive walls of quasi-pulvinated masonry. Vaulted passages lead up to the auditorium at its different levels. The plan, however, is still Hellenistic, the auditorium being extended significantly beyond the strict semicircle of typical Roman theatres, and the stage building, while replacing an earlier one with engaged Doric half columns of the type we have seen at Priene and Aphrodisias (remains of which are incorporated into the Roman structure), is still, like a Hellenistic stage, restricted more or less to the space between the auditorium sides. It is not linked to the sides in the normal Roman manner. The main street that runs directly in front of it, later paved in marble and so generally referred to as the 'Marble Street', is edged with low walls of pulvinated masonry, on top of which ran colonnades in the Doric order. Other buildings were reconstructed in Hellenistic form, such as the Prytaneion at the upper agora (near the Magnesian gate) which uses a late Hellenistic form of Doric columns to support

Fig 41 Opposite, above *The paved street* (Arkadiane) *running from the theatre to the harbour at Ephesos. Columns erected on the paved road halfway to the harbour once carried statues of the four evangelists.*

Fig 42 Opposite *The Prytaneion at Ephesos.*

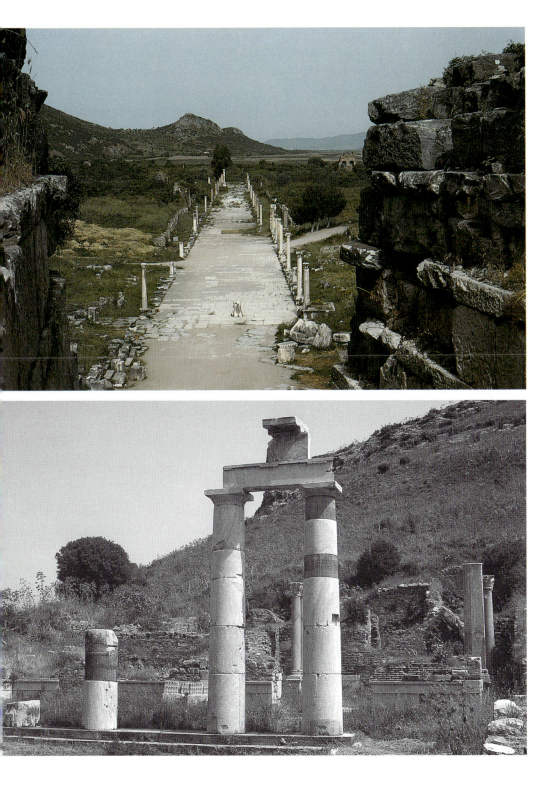

its roof. At the western end of the agora a temple was built, most surprisingly dedicated to the unpopular Roman emperor Domitian (his unpopularity was more a matter for the Romans than the people of Ephesos). Again, this is an example of a Hermogenean pseudo-dipteral building (see p. 77), with a single line of columns on a wide stepped platform, and a monumental altar in front, recalling the arrangement at the temple of Artemis herself outside the city.

In many ways the most attractive of these buildings in the continuing Hellenistic style is the gateway into the main agora, at the junction of the angled and Marble streets, an enclosed Hellenistic-type courtyard. The gateway was built, at the expense of Mazaeus and Mithridates, freedmen of Augustus, into the surviving stoa of the agora at its south-east corner. It has three arched openings (the central one recessed) with pilasters at the corners supporting an Ionic-style entablature, over which is a low attic storey. There are also door-like openings between the passageways with arched niches in the side walls. The

Fig 43 *The gate to the agora at Ephesos built at the expense of Mithridates and Mazaeus, in the course of reconstruction. On the left is the Library of Celsus (see fig. 56).*

whole structure is of limestone. What particularly impresses is the neat, relatively restrained carved decoration which is of a purely Hell-enistic character.

Such continuity is not surprising in areas where a strong local tra-dition of architecture existed. It is discernible, in different forms, away from the Greek Aegean. In Egypt, where the Ptolemies had been forced by Egyptian religious and nationalist pressures to build and decorate temples in a purely Egyptian style, or even add to the vener-able buildings of Egypt's remoter past, as at Karnak, so – at least at first – the Roman emperors considered it prudent to sponsor Egyptian-type buildings, and decorate them in accordance with Egyptian tradition.

What is almost the apotheosis of local architectural influences can be seen at the great sanctuary of Jupiter Optimus Maximus Heliopolit-anus at Baalbek in the Lebanon. The name of the deity is Roman, and resulted from the foundation here by Augustus of a colony, whose settlers were Roman citizens discharged from the legions that fought in the civil war. Their citizenship was undoubtedly recent – the rival commanders in the civil war were not too particular in their recruit-ment of legionary soldiers – and the Roman element is something of a veneer. Heliopolitanus – of Heliopolis, 'sun-city' – is a Hellenism, but the sun god worshipped here in this Hellenistic-Roman guise was the local Baal. His temple stands on a Roman-type podium, high-sided and with steps only at one end; but on top of this is another platform, this time conventionally Greek with steps all the way round. The podium is one which no Roman architect would have designed, or Roman craftsman built. It is made in the local tradition of colossal blocks – particularly those of the great trilithon at the back, three blocks of stone each 4.16 m high, and respectively 19, 19.75 and 18.35 m in length. These recall the description of the walls of Tyre, battered at in vain by Alexander's siege engines, and built of abnorm-ally large blocks of stone – very much a local tradition of building. The temple on the platform was Corinthian, with a ten-column facade in local limestone, the columns having smooth shafts. Here again local tradition is at work. The columns have a wider central column spacing in the Ionic manner, while the frieze is decorated with alternate lions' and bulls' heads, a motif found in some Hellenistic architecture (for example, the Stoa of Antigonos on the island of Delos) but which has

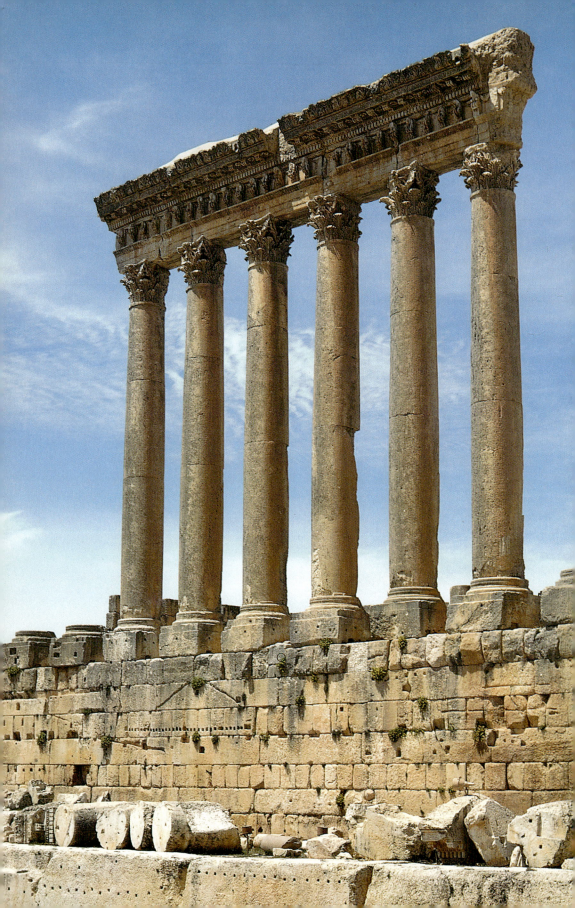

echoes of Persian architecture, as at the great palace of Persepolis.

Later a surrounding courtyard was started for this temple, but never completed. It shows some apparently later features – especially the so-called Syrian arch, the arching of the entablature over the wider central intercolumniation of the propylon at its east end – and is in fact second-century AD in date. But it still retains the large block form of construction, even if it has to adapt it, with some difficulty, to patterns such as semidomes over semicircular insets into walls, which are more easily done, as we shall see, in concrete. This is a later version of the enclosing courtyard, with an unparalleled hexagonal inner court between propylon and main court; but the general idea was already achieved at the temple of Zeus at Damascus (where the temple, of Augustan date, has gone but the surrounding precinct forms the basis for the Great Mosque) and in origin goes back further still, to the enclosing courtyards of Hellenistic temples such as that of Artemis at Magnesia, and – if we only knew more about them – surely some at least of the temples of earlier, Seleukid Syria.

Fig 44 Opposite
*Columns of the great
Temple of Jupiter
Optimus Maximus
Heliopolitanus at
Baalbek, probably
built in the first century
BC at the time of
Augustus.*

CHAPTER 6

The Romans
in Italy

C ompared with the architecture of the Greek cities in the classical period, and even at the beginning of the Hellenistic age, that of Rome was undeveloped and backward. Etruscan temple architecture seems not to have experienced the crucial translation into stone of the original wooden and mudbrick forms when it took place in the Greek world, and so retained its distinctive early characteristics. It is not clear when the full concepts of stone architecture were taken up in the city of Rome; it must have remained a surprisingly backward place even when it was becoming a political power of major significance. There are no real signs of important economic progress; the ever-increasingly strong Roman armies, which by the third century BC had given her control of virtually the whole of Italy, including the Greek cities of the south, were composed of peasant farmers. Objects of wealth and artistic achievement (but not necessarily Roman) are found but not in great quantity. More particularly Rome was slow to develop a system of coined money, which in Greece is concomitant with payment for construction work, and the consequent upsurge of architecture. Until the third century BC Rome's architectural resources were not comparable with those of the Greek cities. She does not have good materials. Though there is a first-rate building stone – travertine – available not far from the city, the stones in its immediate vicinity are of poor quality. This may have helped to retain earlier construction methods; but it also caused the problem, that when better stone was available and Rome had the wealth to import special stone with little restriction on grounds of expense, the older, less-imposing buildings were demolished and replaced with improved structures. Very little in fact remains, apart from architectural terracottas, from the early stage of Roman architecture.

Greek influence

The inferiority must have become apparent by the beginning of the second century BC. Rome had by this time captured and plundered the greatest of the Sicilian Greek cities, Syracuse, and the leading Romans were certainly aware of the attractiveness of Greek art and, presumably, architecture. By defeating the Carthaginians and Hannibal (who, though not a Greek, was in many ways the greatest of the Hellenistic generals) Rome had become a major world power, on a level with the Hellenistic monarchies, with whom she was now negotiating diplomatically; one wonders what impression the Greek embassies we are told called on the Senate in Rome had of the city which exercised such power. Clearly there was a major impetus to develop the city in line with its Hellenistic rivals.

There is then a second phase of Greek influence on the architecture of Italy. It does not come from fifth-century buildings, however much the Romans admired Athens. It comes instead from the contemporary architecture of the Hellenistic cities in the second century BC. It is hardly surprising that Vitruvius, writing in the first century his Latin handbook of architecture, seems to depend heavily on the second-century Greek architect, Hermogenes. This is Hellenistic architecture of a time when the severe fifth-century forms were being discarded in favour of more flamboyant and experimental elements. The Romans did not build fifth-century Doric-style structures, but rather the Ionic of Hermogenes and the Corinthian of – perhaps – Seleukid Syria. Roman entrepreneurs set themselves up in the Greek area; an important example is that of the Cossutii, a family of stoneworkers, one of whom was employed by Antiochos IV as an architect and was responsible for the Corinthian marble temple of Olympian Zeus at Athens. He was surely trained not in Italy but, with his family connections, in the Aegean area; it would have been men like him, and his Greek colleagues, who brought contemporary architectural forms to Rome. We begin to find traces of this at Rome: on the Palatine Hill, a Corinthian temple to the Great Mother Goddess (herself imported from Asia Minor during the Second Punic War) in poor quality local stone and very fragmentary; and the small temples in the Largo Argentina, though these underwent subsequent improvement. White marble

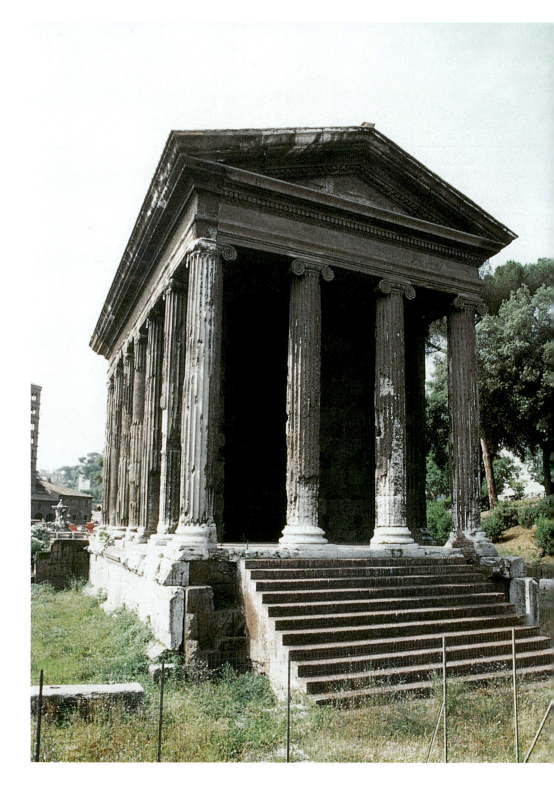

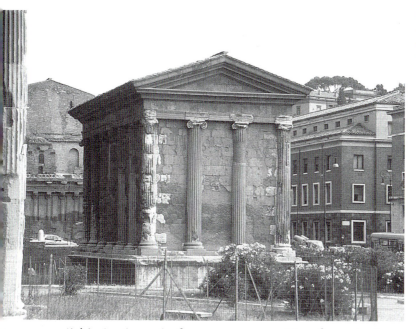

became available in the early first century BC, either from the Luna (Carrara) quarries of northern Italy or from Greek quarries. Good examples of the impact of all this are two little temples in the Forum Boarium near the Tiber, one Ionic, on a Roman-type podium, with four columns to its facade and (a Hellenistic touch) engaged half columns attached to the side and rear walls; the other Corinthian (with very fine capitals which must have been carved by craftsmen familiar with Hellenistic form), circular in plan on a low-stepped base. These, in effect, introduce the way the Hellenistic impact is going to be made, the details of the orders and their employment derived from the Hellenistic East, but employed on buildings which are adaptations of the traditional Roman forms of temple (the Greeks may have built circular monuments but not circular temples). Both date to the early years of the first century BC.

Possibly of the same period, though some scholars have suggested a date around 130 BC, is a very different building, the great sanctuary of Fortuna Primigenia at Praeneste (Palestrina) outside Rome. This introduces the greatest single contribution of the Romans to architecture: concrete. The property of lime mortar (and the related but less stable gypsum mortar) had been known in the Near East since the Bronze Age, and had been used by the Greeks to bind stone together

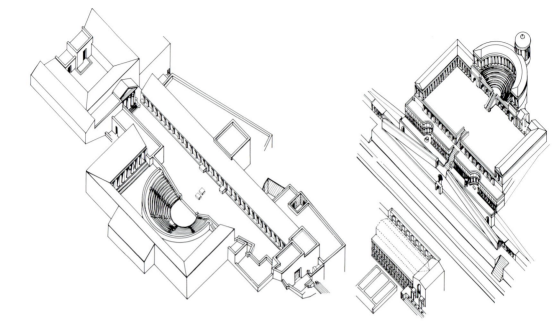

Fig 46 *The*
sanctuaries of the Syrian
goddess Atargatis at
Delos (left), and of
Fortuna Primigenia,
Praeneste.
Reconstruction
drawings.

to form waterproof cement floors in dining buildings and waterwork
structures (such as Perachora). Wider use was probably prevented by
the cost of preparing the quicklime, but at some point, at least by
the early second century BC, the Romans discovered that a natural
volcanic material quarried near Puteoli (Pozzuoli) which they called
'pit sand' (now known as pozzuolana) had the property of extending
the mortar, and, most strangely, allowing it to solidify even when
immersed in the sea for harbour works (presumably an early use
though this cannot be confirmed archaeologically). Use of pozzuolana
considerably reduced the cost of mortar and, properly used, increased
its binding power. Even though in the late first century BC Vitruvius
is still highly suspicious of it, believing it dries out and then collapses,
and though presumably there were failures during the experimental
period, buildings with walls of rubble held together with cement were
being put up in Rome during the second century BC. The sanctuary
of Fortuna was built by architects who were fully confident in the
properties of concrete and handled it with imagination, forming from
it not only massive support walls for terraces, but also curved, vaulted
roofs incorporated into the overall design.

At the same time, the building reflects Hellenistic architectural

concepts even when using this non-Greek building material. The sanctuary comprises a series of terraces, faced with concrete walls and embellished with colonnades; approached by ramps and staircases up the slope of the hillside, the small shrine building at the top surmounted a theatre-like construction, from which no doubt worshippers could watch the performance of some religious ritual. A similar sanctuary, on a hillside with a shrine at the top above a theatre-like section which overlooks terraces, exists on the island of Delos, dedicated to the Syrian goddess, Atargatis. This dates towards the end of the second century BC; if it is the inspiration for Praeneste, that sanctuary must be later. If Praeneste is earlier, then the inspiration for both of them must be sought elsewhere, presumably in Seleukid Syria. There are other, smaller sanctuaries near Rome which are influenced by Praeneste, but this does not establish a precedent taken up with enthusiasm in Italy.

Civil War and Augustan renewal

The first century BC saw the outbreak of the great series of struggles for personal political power within the Roman system known as the Civil Wars. They dominated Roman history and squandered its resources. There was widespread damage to buildings, even in Rome itself, and a virtual (but interrupted) cessation of construction. One new building which was put up (but of which little is now visible) was the first permanent theatre building, erected by the politician Pompey at the height of his political power. It was built on flat ground, unlike the Greek theatres, and needed considerable substructure to support the auditorium. This was achieved in concrete. The plan of the theatre was supposedly based on that of Hellenistic Mytilene, on the island of Lesbos; but it is known that the auditorium was a strict semicircle, unlike the Greek theatres which are always larger than the semicircle, and the real origin is probably the wooden theatres which were used for dramatic performances earlier in Roman history.

An architectural revival began under Julius Caesar, thwarted by his murder and further civil war. When the war was eventually ended by the victory of Octavian (later known as Augustus) over Mark Antony, the city was in a most dilapidated state, and much renewal was neces-

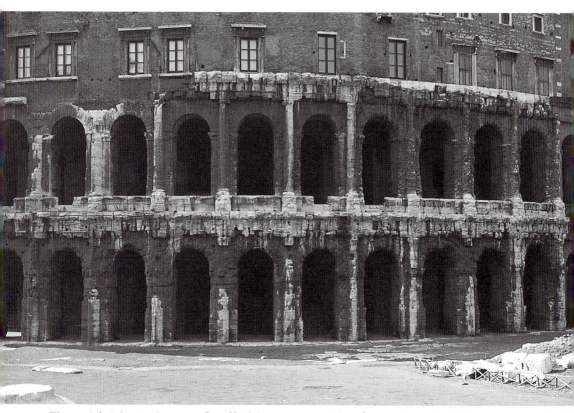

Fig 47 *The Theatre of Marcellus at Rome, from the outside of the auditorium.*

sary. In all this, concrete played a major role. The resources of the Mediterranean, in material and above all finance, were increasingly in the hands of the emperor (as Augustus reigned) and something more magnificent was possible. In the Hellenistic East, architectural prestige was in marble, and this now had to be the same at Rome. At the same time Augustus, in a sort of 'back to basics' policy, wanted to restore the old strengths and virtues of Roman religion. The result was the construction (or, much more often, reconstruction) of a large number of temples (over eighty) in which the traditional Roman podium-type was inevitable; but they were now clad in marble, using the developed forms of the Hellenistic orders, Ionic and above all Corinthian, and often placed in enclosed courtyards (*porticus*), derived from the Artemis at Magnesia type. This style had been started by Julius Caesar with his temple to the ancestral deity of his family, Venus Genetrix; this 'Forum of Julius' was completed by Augustus, who then built his own adjacent 'forum', with its temple of, appropriately, Mars Ultor, 'Mars the Avenger'. In these and other temples

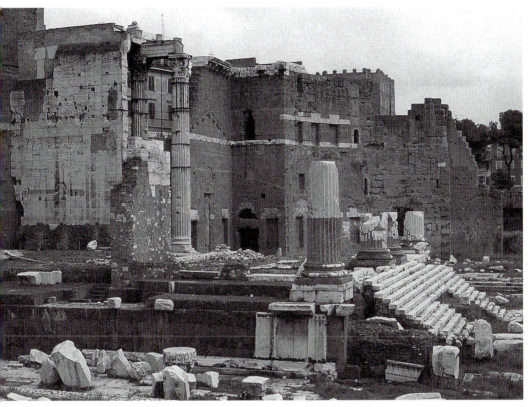

another important Roman innovation can be detected. Many of them have roofs with spans of 20 m or more with no internal supports. These cannot be due to the availability of even vaster timbers. Though of course none of the woodwork survives as proof, some means of joining timbers together, probably in triangulated trusses, must have been employed to make these spans possible. As a result, the interiors are large and uncluttered; more emphasis could be placed on their embellishment, and much more complex systems of internal decoration, with columns placed against the walls, with stucco work and applied cladding of decorative and coloured stone, helped to serve this new emphasis.

Fig 48 *The Temple of Mars Ultor in the Forum of Augustus, Rome. It is built of marble, but concrete has been used in the substructures.*

Roman public buildings

If temples for reasons of prestige had to be of stone (they may have had concrete substructures, and at times an end apse surmounted by a moulded concrete semidome), concrete became the chosen material

for other structures. Particularly important are the bath buildings
Bathing facilities had been part of the Greek way of life, mentione
in the literature of the fifth century BC, but had never developed
distinctive architectural type. Wash places – even pools – are occasion
ally found attached to sanctuaries and particularly gymnasia – ther
is an excellent example at Delphi. These concepts passed to Italy, an
here more emphasis was placed on the bathing than the exercise. Bath
buildings provided sequences of cold to hot baths, and with thi
developed also a distinctive social significance. Warm baths wer
heated by means of a hypocaust – a Greek term – where hot air from
a furnace passed into a space under a raised floor. Rooms were place
side by side with no special architectural design, except that th
interiors were often luxuriously decorated. The Stabian Baths at Pom
peii, in their developed form (first century BC), are a good example
Concrete was obviously useful, since it would stand up to water an
was fireproof. Roofs became concrete vaults. During the first centur
AD the bath building as an amenity for the general populace wa
developed on behalf of the emperors. The scale became increasingl

Fig 49 *The courtyard
(palaestra) of the
Stabian baths at
Pompeii.*

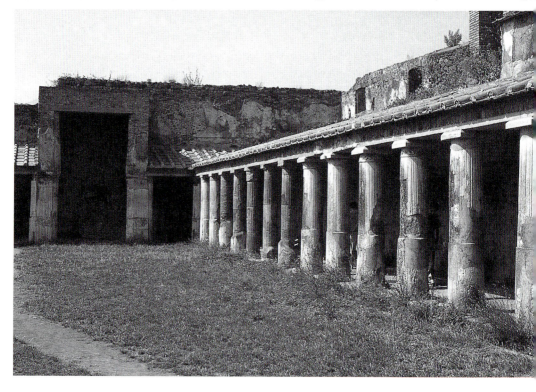

MAGRIPPA·LF·COS·TERTIVM·FECIT

Fig 50 *The exterior of the Pantheon at Rome. The modern road level obscures the original steps.*

grander, and the plan more rigorously organised, symmetrically about a great central room, the cool room (frigidarium), which had high vaulted ceilings and the most lavish of decoration – tall columns by the walls, cladding of expensive coloured stone, fine stucco work. For this was the great social room – there were small pools attached to it and a swimming pool nearby, but this was a place where one lounged and gossiped. It was in such structures that the full potential of concrete came to be realised.

These concepts were adopted for the one temple whose form depended on concrete construction, the unique, splendid – and intact still at the present day – Pantheon, shrine of all the gods (and including the deified emperors). It was originally put up in the reign of Augustus, when its form was uncertain. This was replaced early in the second century AD by the emperor Hadrian who, however, did not put his name on the building, retaining instead the original dedication by Marcus Agrippa (Hadrian's involvement is proven by the stamps on the bricks used in the construction). From the outside, from the courtyard in front of it, the Pantheon was intended to appear as a conventional rectangular temple, with a porch of eight Corinthian columns,

Fig 51 *The interior of the Pantheon with, visible in the top right-hand corner, part of a section of the upper level of wall decoration restored to its original form.*

with monolithic shafts of Egyptian granite. But from the porch one passed into the circular cella, 150 Roman feet in diameter and covered with a great concrete dome, all lit only from a circular opening at the top of the dome, the oculus, from which a shaft of sunlight would pass with the movement of the sun round the surface of the dome and wall. The dome appears to rest on a solid wall, but such was the confidence the Roman builders now had in their concrete techniques that in reality the wall is reduced to a series of eight hollow piers; the space between them is screened by colonnades and thin, non-load-bearing curtain walls, while the weight and thrust of the dome is transferred to the piers by arches contained within the structure. The interior is a fine example of Roman decoration, with its proportions carefully calculated. The diameter of 150 feet is repeated in the height to the top of the dome. The wall section is divided by an entablature and string course in proportions of 1 to the square root of 2. The taller bottom section is punctuated by niches, alternately squared and semicircular, which once contained statues of the gods, with columns maintaining the line of the wall and supporting the dividing entabla-

ture. Between them, the walls have patterned cladding of coloured stone slabs. The upper section was also decorated with cladding, to represent pilasters framing window grilles which, however, did not pass to the exterior and admitted no light (one section has been restored to its original form; the remainder is altered by eighteenth-century plasterwork). On the outside the drum was brick-faced and stuccoed. The porch is attached most awkwardly, by an intermediate rectangular section of greater height. It has recently been demonstrated that the porch (which is quite squat in its proportions) was originally intended to be higher, with columns fully sixty Roman feet in height. Presumably these were not delivered (possibly lost at sea on the journey from Alexandria) and had to be replaced by fifty-foot columns, the largest available.

Equally important for their influence on later architecture are the buildings with exterior arcades. Probably the oldest is the Tabularium, the Public Records Office, built on the slopes of the Capitol Hill above the Forum, now largely cased with later facing, but with one section of the original arcade revealed. The arches – in travertine – were

Fig 52 *The Flavian amphitheatre (the 'Colosseum') at Rome. The lowest arcade (as also in the Theatre of Marcellus) is decorated with the Roman version of Doric.*

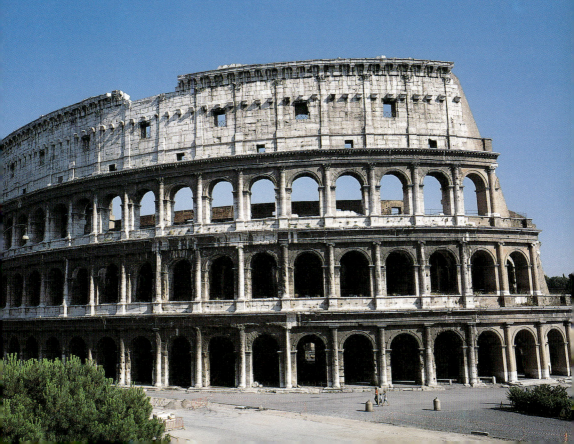

supported on piers, to which half columns were attached, as high as the top of the arch and supporting a continuous entablature. This proved to be the solution to the problem of incorporating arches – which invariably formed the outer faces of concrete vaults running into the structures – into the conventions of the classical orders. These facades echoed the rhythm of the multi-storey stoas. Where they were used for the exteriors of higher buildings, such as the outer walls of the auditoria of Roman theatres, they were generally arranged in the sequence Roman Doric for the bottom storey, then Ionic, then Corinthian. This was used – with an uppermost storey formed from an attic without the arched openings – for architecturally the most stupendous of Roman buildings, the great Flavian amphitheatre known as the Colosseum (which, ironically, got its nickname not from its size but from the fact that it stood on a site near where Nero had created a colossal statue of himself). The contrast between its architectural quality and the purposes to which the building was put is one of the ironies of Roman society, at least as perceived by modern eyes.

Another important category of building developed at Rome is the basilica (though the Greek name may indicate a Hellenistic origin for the type). This is in effect a stoa widened to comprise a central nave and flanking aisles (the Christian church form of course derives from it). It may be entirely open along one side, but most frequently is enclosed, with entrances either at one end or one side. The other end (or both, if entered from the side) contained a platform for a magistrate, the tribunal, from which he conducted official, particularly legal business. Early examples are known to have been built in the second century BC. There are examples in the Roman Forum (the Basilica Julia, with an arcaded facade, and the Basilica Aemilia, rebuilt under Augustus). The greatest are the Basilica Ulpia, in Trajan's Forum, which unlike the Pantheon retains the traditional, expensive but prestigious construction with columns and timber roof; and the later Basilica of Maxentius and Constantine, of brick-faced concrete, like the great hall of a bath building standing in isolation. Basilicas were a universal type of building, like the Greek stoas which to some extent they replaced, used for a multitude of official and commercial purposes.

Roman houses

Concrete also came to be used for houses. The traditional Roman house type, like the Greek, was basically single-storeyed, but with rooms arranged to a strictly axial plan (if the building plot allowed – many at Pompeii are not) round a central atrium. Though, like the Greek courtyard, from which it probably derived, this atrium had a pent roof covering all but a central opening through which rainwater might be collected. The main difference between Greek and Roman houses was a much greater sense of formality in the Roman, with a principal reception room (the *tablinum*) for clients and guests, which was designed to impress and normally placed directly across the atrium from the entrance. There is an example of a rather splendid house of this type, the so-called House of Livia, on the Palatine Hill at Rome, one of a series of houses built for members of Augustus' family; later generations turned the Palatine area into a palace. As the population of Rome grew, these houses had to give way, as at Alexandria, to multi-storey tenements, similar in arrangement to the Alexandrian examples, but often flimsily built, with much timber in their construction. It was this that led to fires, culminating in the great fire of Nero's reign. Concrete brick-faced walls and solid floors then gave a superior fireproof structure. Unlike the inward-looking atrium houses, these tenements had apartments with balconies and windows on their exterior; they established a type of dwelling place which became traditional for Italian cities and survives to the present day. In contrast stood the palaces, the most magnificent houses in Rome, with great courtyards: one for public functions, feasting perhaps, so that it had a few very large rooms; another, private, with smaller rooms, including the more intimate triclinia, rooms with three wide couches on which guests could recline with their heads towards the centre.

The ideal Roman dwelling place, however, was the country estate, the villa. Often placed to command attractive views, outward looking, with curved walls and formal gardens, these represent a category of architectural paradise most fully realised by the emperor Hadrian with his vast estate at Tivoli, with an array of separate pleasure buildings, dining halls and gardens where the fluidity of Roman concrete design reached perfection. Sinuously arranged colonnades, domes and awn-

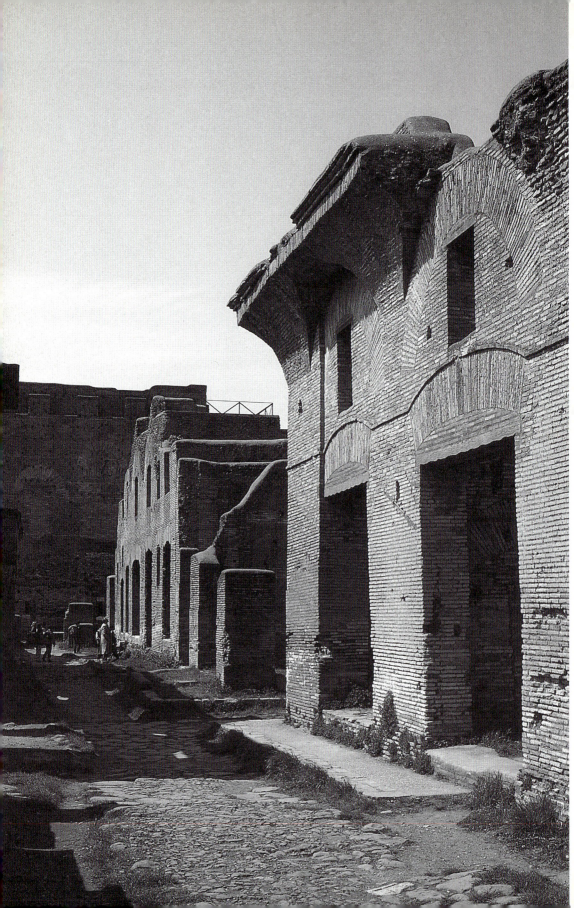

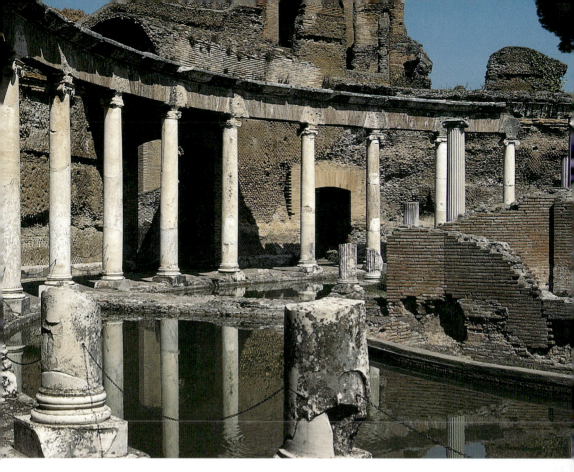

ings, elaborate wall decoration, fine patterned floors in mosaic and cut stone, statues and monuments – all were made possible by the wealth the empire – and the emperor – controlled.

Fig 54 *The island dining pavilion* (maritima) *of Hadrian's 'villa' at Tivoli.*

Fig 53 Opposite *Tenement houses at Ostia built of brick-faced concrete.*

CHAPTER 7

The Roman Empire
in the East

The Roman empire was divided for administrative purposes into provinces, each with a Roman governor and, where they were needed, Roman legions. But much responsibility rested with the local people, undertaken through the city organisation; in the eastern area, a continuation of the cities which had existed under the Hellenistic kings. These cities had no military function, and no real independence. Yet they competed with each other, particularly in architectural display, and during the long Roman Peace of the second century AD constructed very large numbers of imposing buildings – indeed, it has been argued that this expenditure was so excessive that it led directly to economic difficulties in the following troubled years of the third century. The finance behind the architectural flourish was not generally administered by the cities themselves, but by members of the wealthy land-owning families, for whom it was a matter of prestige that they should spend their wealth on gifts of buildings and monuments – bearing, of course, their names – for the benefit of the cities that at the same time they dominated politically. On occasions, the donations were spread more widely. Herodes Atticus who lived in the second century AD was a Roman senator and a friend of the emperor Marcus Aurelius. He owned vast estates in different parts of Greece, in the Peloponnese and in Attica, where he had a sumptuous residence at Marathon. He was responsible for the construction of a Roman-type theatre in Athens, at the other end of a long Pergamene stoa (given by the Hellenistic Pergamene king Eumenes II) from the Theatre of Dionysos. Herodes' theatre, however, has the regular Roman semicircular auditorium linked to a high stage building. He also gave an enormous fountain monument to the sanctuary of Zeus at Olympia, a semicircular construction most ornately decor-

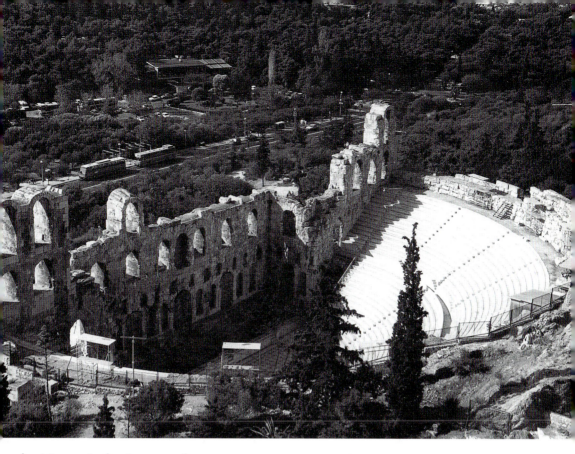

ated with attached columns and statues.

Such ornament is typical of the period. It consists, essentially, of diversifying the surfaces of walls by attaching to them screens built up from sets of small columns and pediments, the niches created being most suitable locations for statues.

Ephesos under Rome

A good example of such ornament is shown on the library donated to the people of Ephesos in memory of Gaius Julius Celsus Polemaeanus and his wife. Celsus, a native of Sardis, had served Domitian as clerk of works in Rome and was subsequently governor of the province of Asia and so a resident in Ephesos. On his death he was given the extraordinary privilege of being buried within the city limits, in the library which is his monument. It is situated at the crucial junction of the Marble Street and the angled road that leads up to the Magnesian gate, facing on to a small paved courtyard which also contained a circular Hellenistic monument and, at its side, presenting a noticeable contrast to the baroque exuberance of the library, the sober Hellenistic-

Fig 55 *The Theatre of Herodes Atticus, Athens, looking down from the acropolis. The seating is restored.*

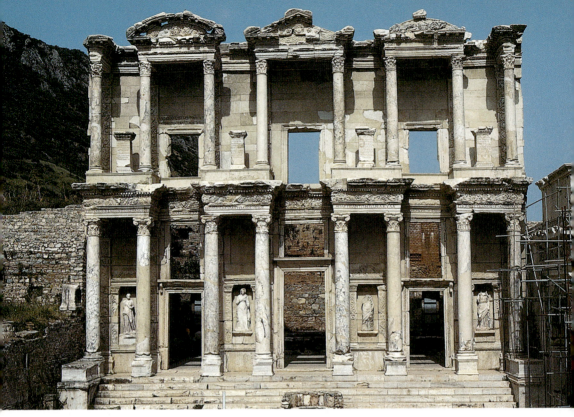

Fig 56 *The Library of Celsus, Ephesos. The façade has been restored from the original fallen blocks.*

style gateway of Mazaeus and Mithridates described above. The library of Celsus is approached up a broad flight of steps leading to the doorway. Inside was a large rectangular room, the walls ornamented with columns but devoted essentially to the pigeonhole-like receptacles which held the books (which were, of course, scrolls, not books as we understand them). Running behind this wall was a narrow passage, which seems to have served as a cavity between the inner and outer walls to prevent damp spoiling the books – an interesting practical consideration. Beneath the centre was a chamber containing the sarcophagus of Celsus, visible through an opening. The main embellishment was on the exterior, facing up the angled road. This was frankly intended as an eye-catcher, visible to everyone walking down that road. The screen is two-storeyed. On the lower level, on plinths set forward from the facade wall, are pairs of composite columns, whose capitals surmount a Corinthian-style bell with Ionic volutes. These have smooth shafts, and carry a horizontal entablature. They frame statues personifying the moral qualities of Celsus, his virtue, his wisdom. Over them the second storey also consists of pairs of columns, but in this case arranged to bridge the spaces between the lower pairs, resulting in single isolated columns at either end. These carry

riangular and segmental (curved) pediments. The result is decorative,
not structural, in contrast to the architecture framing the entrance to
he agora in Mithridates' gate. The contrast is emphasised by the
carved decoration. Where the gate has the restrained and limited
decoration of classical form, the library is a riot of complex carved
patterns (though the use of statues between an architectural frame
goes back to the tomb of Mausolus, and was followed in other burial
monuments both Hellenistic and Roman). The result ought to appear
vulgar and overblown; in reality it is both attractive and impressive,
and it is easy to appreciate why this style would have seemed appropri-
ate to the self-advertising purposes of those wealthy second-century
amilies.

At Ephesos this architectural transformation can also be seen in the
gymnasia, of which there are many examples (the equivalent of the
Roman bath buildings). These remain dedicated primarily to athletic
activity, and are approached through large, enclosed colonnaded exer-
cise grounds. Across one end, however, is a suite of bathing rooms
providing facilities comparable to the Roman baths, but arranged in

Fig 57 *Restoration of
the principal room of
the courtyard at the
Harbour Baths,
Ephesos. The woodwork
of the roof probably does
not represent the ancient
system.*

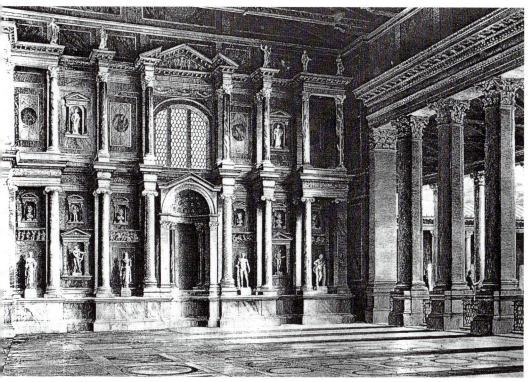

a different manner. It is here that the absence of Roman concrete construction in the eastern provinces is noticeable; roofs are either of stone vaults or of beamed timber construction. There is not, therefore the same feeling of great spaciousness of the imperial bath buildings but rather of suites of smaller rooms. One room, however, is singled out for more lavish treatment; opening from a courtyard it is an enlarged, embellished version of the exedras, open fronted room behind the courtyard colonnades of the classical gymnasia. The decoration comprises the screen system, columns against the walls with ornate entablatures, and framing niches for sculpture, all in marble and other coloured exotic stone, and combined with ornate patterned floors. The wooden ceilings, of course, are lost, and there is no way of reconstructing their appearance, but comparable lavishness must have been employed on them.

Perge, Aspendos and Side

Equally delightful are the lesser towns, which did not have the benefit that Ephesos enjoyed of being the seat of the Roman provincial authorities. Good examples are the cities of Pamphylia, on the south coast of what is now Turkey. These places – Perge, Aspendos, Side – like Ephesos, were old foundations, and were already flourishing as Greek cities in the Hellenistic period – Perge, in particular, has well preserved and substantial Hellenistic fortifications. They reached their zenith in the second century AD, when, in a quiet and peaceful provincial way, they must have been very pleasant places in which to live. At this time they made no impact on history but they are excellent examples of what Roman prosperity meant to the inhabitants of this part of the empire. They all have large, built Roman theatres, those at Perge and Aspendos with auditoria resting on the hillside in the Greek manner, while Side has built substructures, which however are made entirely from vaulted cut stone blocks, without the use of Roman concrete. All are of the strict semicircular type, with linked, high stage buildings. Aspendos is structurally the best preserved, the wall of the stage building still standing to its full height, though it has lost most of its ornate screen decoration, with only the plinths and built parts of the three-storey system of decorated niches preserved

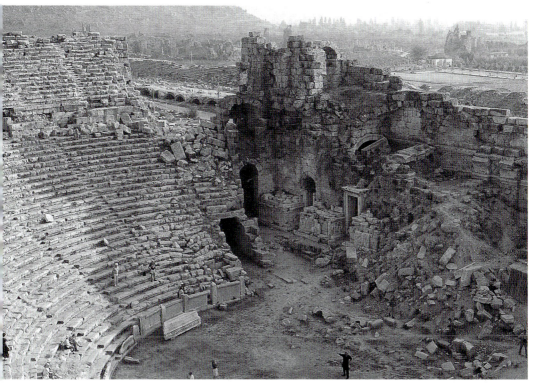

Fig 58 The Theatre of Perge, Pamphylia. Behind the stage building can be seen the vaulted substructure of the stadium and, in the right-hand background, the main city gate.

Perge has collapsed as the result of earthquake, but the fallen pieces are being sorted out and replaced in position by Turkish archaeologists; when complete, this will give the best example of one of the baroque screens, but already the flavour of it is emerging at the lower levels. In front of each stage building was a relatively shallow but long stage (entirely disappeared at Aspendos) on to which opened five doorways in the screen wall at the back – a main large doorway at the centre, flanked by lesser doorways to each side, and small doorways at the ends. Again, these are examples of continuity, deriving from the three doors which provided the standard setting for all classical plays (three doors for comedy, one for tragedy, while people coming from farther than the immediate context of the play entered from the side). The walls are built of large ashlar blocks in the local limestone; the screens are of marble and coloured stone. The preserved and restored sections at Perge have lavish decoration to the mouldings, and are ornamented with panels of sculpture.

Perge had a different, but magnificent example of architectural embellishment which formed an amenity rather than a building in the

Fig 59 Opposite *The interior of the Great Hall at the sanctuary of the Egyptian gods at Pergamon, built in mortared red baked brick.*

strict sense. The main street runs from an ornate gateway building an elaboration of an entrance which originated in the Hellenistic fortifications, towards the acropolis-like hill on to which the tow extended. At the foot of the hill, and forming a visual termination t the road, was an elaborate fountain. Water flowed from this along series of stepped pools down the middle of the road, with occasion footbridges over, almost like the central reservation in the middle a dual carriageway. To either side the road was colonnaded. The tot ensemble must have given an appearance of wealth and ornament though serving no utilitarian purpose except perhaps as a place up an down which people could stroll, the heat of a Mediterranean summe abated by the cooling stream.

Other buildings at Perge – a gymnasium, for instance – and a Aspendos – a tall fountain building, for water brought some distanc to the top of the acropolis hill by a substantial aqueduct – were bui essentially of the local limestone but given ornate screens of column and niches in more expensive stone, now robbed away. A good surviv ing example has been partly restored at Side, in a building to one sid of the agora, with a cladding of marble columns which, at the corners contain an inner decorative element, a niche with a shell carving ove it, again in marble. Building methods are essentially a continuatio of traditional forms; it is the ornamentation which represents a Roma development.

In contrast to these traditional building methods, one particula building in mortared brickwork stands out. This is the sanctuary o the Egyptian gods, Isis and Osiris, at Pergamon, not on the hill o the Hellenistic city, but the more convenient flat ground of the valley A large area was created for this by building a long double tunnel stone vaulted, to cover a river. The sanctuary itself is built of bake red brick, mortared together. Unlike Roman brickwork this is not facing for rubble concrete; the walls are entirely of coursed brick. T this was added marble embellishment – two flanking colonnades, an marble string courses inserted into the brickwork, particularly t accentuate the clerestory windows of the main section. There are tw elliptical-plan wings, one to each side, surmounted with flat domes One, still intact, has been converted into a mosque. It is difficult t see where the inspiration for this came from. Another building a

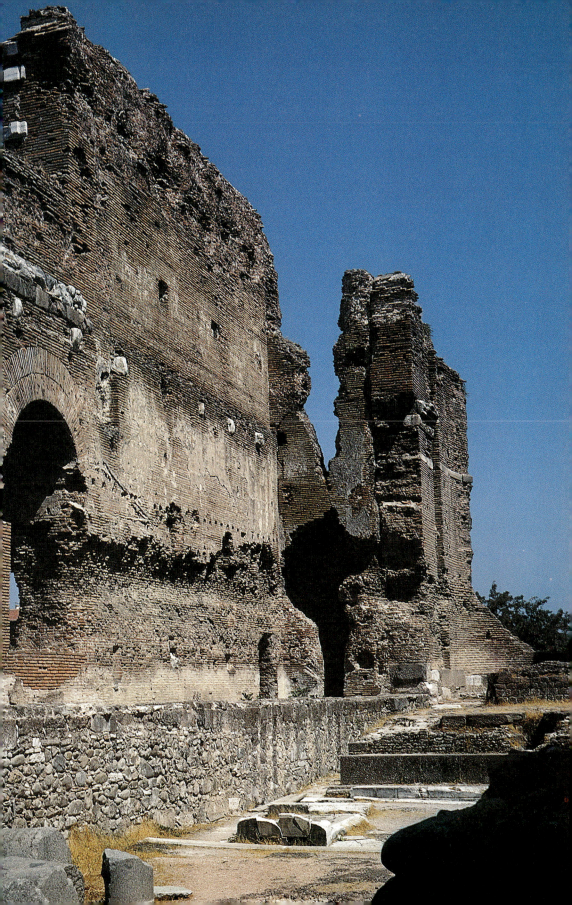

Pergamon, outside the town, a temple dedicated to Asklepios by Appius Claudius Charax (who also dedicated the Bridgeness slab at the end of the Antonine Wall in Scotland), is uniquely based on the Pantheon at Rome; but no Roman building could have served as a model for the Egyptian sanctuary. More likely the antecedents should be sought in Egypt, perhaps at Alexandria where baked brick is used in mortared work of the Roman period, though it does not have the quality of the Pergamene brick.

Roman Syria and Jordan

The ornate forms of architectural decoration are found in abundance in Roman Syria. A good example survives in the interior of the second lesser temple at Baalbek (lesser, but still larger than the Parthenon) presumably dedicated to the moon goddess. This stands outside the precinct of the temple of Jupiter. Like Jupiter, it is constructed in the megalithic tradition, though externally it is purely Roman in form, standing on a high podium. There is a particularly ornate doorway, obviously used only for formal religious occasions, since there is a small, more utilitarian portal next to it. The main doorway has a frame which derives from those of Ionic temples, but is more generous in its application of carved decoration to the mouldings. The lintel was too wide to be made conventionally from a single block; instead it is built as a flat arch, a method used earlier in the temple of Castor in the Forum at Rome. The external colonnades – which are well preserved – have smooth shafts like the temple of Jupiter, and the entablature also echoes the larger temple. The interior, however, has an engaged screen decoration of fluted Corinthian columns against the wall, the entablature being broken forward from the wall to project outwards over each column, denying it any real structural purpose (which, of course, it does not have) and using it simply as enlivened decoration. A similar broken entablature occurs on the exterior of the library built by Hadrian in Athens, which may be a little later in date than the Baalbek temple. The back of the cella at Baalbek received a distinctive treatment, to give emphasis to the cult image which stood there. A broad staircase rises up over a crypt, which is entered by a doorway at the right-hand side. At the top of the steps is a structure

in exotic stone, columns supporting a low curved vault, less than the full semicircle, and fronted with a broken segmental pediment. Even more restless is the third temple at Baalbek, a much smaller circular structure, the base formed from a circle of linked concave niches, the columns being placed at the projections between them.

Roman Syria and adjacent places, such as Gerasa in Jordan and Palmyra, are typified by the use of colonnaded streets, of which we have encountered some examples in Asia Minor. At Gerasa such a street leads off a vast paved oval space, surrounded by Ionic colonnades. It is usually called 'the Oval Forum', though it does not seem to have the buildings needed for a true forum, and the columns do not form the face of porticoed buildings, which they do when they line a forum area. It seems to be a gathering place, but how it functioned is quite uncertain. It leads to a colonnaded street, from which at right angles another colonnaded street leads up, past a monumental three-arched gateway structure, to the principal temple. But it is Palmyra where the colonnaded streets are found in the greatest abundance. This is an old city long predating the Hellenistic and Roman periods (when its name was Tadmor). It flourished as the jumping-off point for the

Fig 60 *The colonnaded streets of Palmyra (from Wood and Dawkins'* The Ruins of Palmyra*).*

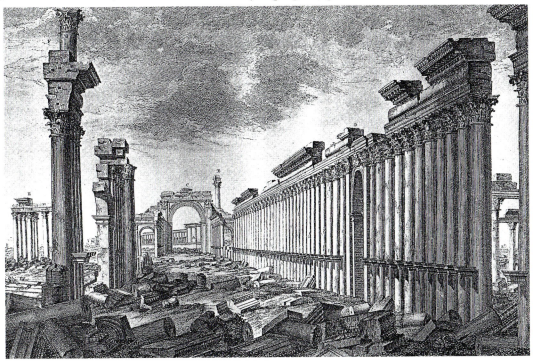

direct, cross-desert trade route to Mesopotamia and the East, and became very wealthy in the second century AD and even well into the third century, when its ruler held the Roman empire in the East together under his own authority. All the main streets in the formal centre of the town were lined with colonnades, though in one street they stop short, unfinished when the authority (or audacity) of the town collapsed. The columns are tall, smooth-shafted Corinthian, and have, two thirds of the way up the shaft, projecting brackets which presumably carried statues. At one point a change of alignment in the street is masked by a triple archway, its two faces perpendicular to the different alignments and together forming a triangular structure.

Undoubtedly the most ornate and complex architectural forms are found at another of these eastern places on the fringe of the Roman empire, the famous rock-cut tombs at Petra, the chief town of the Nabataean Arabs, incorporated into the Roman empire by Trajan in AD 106. These typically consist of a lower storey, with a doorway leading into the burial chamber, and an upper attic storey, a division also found in Hellenistic rock-cut tombs of Alexandria, such as the

Fig 61 *The 'chapel' in the catacomb of Kom-el-Shugafa, Alexandria.*

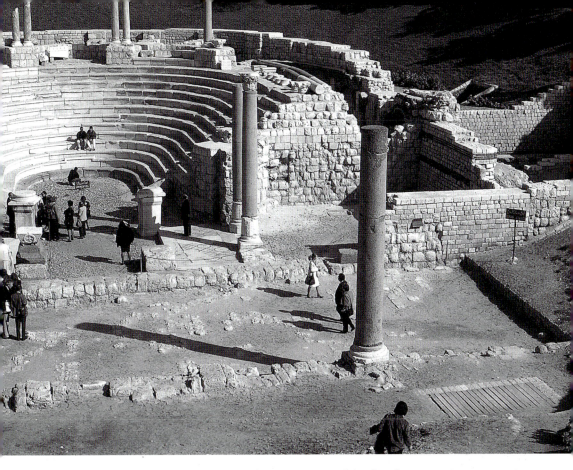

careful Doric examples at Mustapha Pasha. At Petra some of the facades are much more ornate, no doubt depending on the wealth of the family responsible for the tomb. The lower storey is given 'columnar' decoration, which may be repeated for the upper storey. Stepped triangles may be added over this to either side. But the most ornate combine this with an arrangement of broken pediments, often framing, over the doorway, a rock-cut impression of a circular monopteral structure with its own conical roof.

Alexandria is likely to have provided the inspiration for these fantasies, and it is doubly unfortunate that little survives there. What does survive includes some vast rock-cut catacombs; that at Kom-el-Shugafa has, deep inside (and now partly submerged by the rising water table), a chapel for funerary ritual decorated in a strongly Egyptianising style, but with portraits of the occupiers in very Roman style and wearing Egyptian dress. Another, at Mex, has at its centre a large room with a shallow rock-cut dome (which seems to imitate the 'real' architecture found in the world of the living) from which lead small chambers arranged into the dining triclinia of Roman buildings. So

Fig 62 *The Roman Theatre and colonnaded street of Kom-el-Dik, Alexandria.*

the architectural forms there are mixed. Otherwise at Alexandria there are numerous Corinthian columns and capitals detached from buildings but cut from exotic stone; and fragments of porphyry decoration that was part of the temple of Serapis. Most distinct are Corinthian columns with acanthus decoration on the lower part of the column shaft; stray examples survive, the earliest perhaps Hellenistic rather than Roman, but a whole series have now been found lining a street by a small Roman theatre in the area Kom-el-Dik, which, with its tenement houses and an elaborate, late bath building is now the best preserved part of a city whose almost total loss is perhaps the most serious gap in our appreciation of Greek and Roman architecture.

The Roman Empire
in the West

Unlike the eastern provinces of the Roman Empire, those in the west had no real traditions of architecture. The only exceptions to this were the Greek colonies on the south coast of France, of which the chief was Massalia (Marseilles), and the Phoenician (Punic) settlements in North Africa, such as Carthage, and its off-shoots on the coast of Spain. These came under Roman domination as a consequence of the wars with Carthage in the third and second centuries. Later Rome expanded from there to occupy the whole of Spain and Gaul, extending first to southern Gaul (Provence, the 'Provincia' in the first instance) and then the less sophisticated hinterland. These areas had been in touch with Greek civilisation for some time. The silver of Spain was an attraction to the Samians already in the seventh and sixth centuries BC while Greek artefacts travelled up the valley of the Rhone and beyond, as far as Vix, a mere 100 km south of Paris. The tin resources of Cornwall were known to the people of the East Mediterranean, and a Greek mariner, Pytheas, sailed into the North Sea at some time in the fourth century BC. But all this was superficial. There was some influence of Greek masonry techniques and styles from Massalia on the Gaulish hillfort settlements away from the coast (such as Entremont, near Aix en Provence) but that was all.

Urbanisation

The western provinces were finally pacified by the time of the emperor Augustus, and after an abortive attempt to subjugate the German tribes, the frontier was established on the line of the Rhine and Danube; the only subsequent modification to this in the west being

Fig 63 *Gallic masonry at Entremont near Aix-en-Provence.*

he incorporation of the re-entrant territory between the upper Rhine
nd Danube behind a linear defensive system towards the end of the
rst century AD. Britain remained outside, until invaded by the
Romans under Claudius in AD 43. Attempts to control the whole of
he island were only sporadically maintained after the end of the first
entury AD. To rule this enormous area, the Romans extended the
olicy of urbanisation which they had inherited in the regions of the
astern Mediterranean, making the cities responsible for much of local
dministration, and for the public expression of the virtues of Roman
ontrol. Invariably these cities were new creations, and their basic
ayouts planned, though very often they replaced an earlier, native
entre of population, generally referred to as 'hill forts', but which
vere in places already sizeable communities. A good example is the
irge fortified site of Mont Beuvray, in central France, whose popu-
ition was moved down into the adjacent plain to form the large city
f Augustodunum – the use of the emperor's name is significant – the
nodern Autun. To strengthen this process, colonies of Roman veterans
vere also planted, such as Nîmes and Arles in Provence, and, perhaps
ither more artificially, Colchester after the conquest of Britain,

Fig 64 *The Maison Carrée (the Capitolium), Nîmes.*

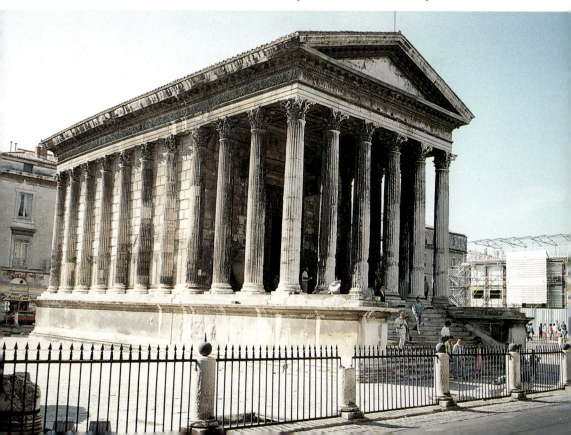

though here the original colony was destroyed in the rebellion of Boudicca.

Such towns were more than extensions of the Roman political system. They had to be equipped with the buildings which by this time were normal in the cities of Italy, and in the initial stages, at least, these must have been achieved by architects and even the necessary craftsmen from established Roman centres. The results, needless to say, are virtually indistinguishable from buildings in Italy itself. An outstanding example is the principal temple of Nîmes, known as the Maison Carrée. Because it has been constantly in use as a building ever since its construction, albeit for very varied purposes, it is remarkably well preserved. It has a modern replacement roof, and there are other repairs, but essentially this is a high quality temple of the developed metropolitan Roman type. It stands on a podium, has a facade of six Corinthian columns, and a cella that extends for the full width; the impression of side colonnades, as with the Ionic temple by the Tiber in Rome, is achieved by means of engaged half columns. The temple was an imperial gift; traces of the fitting of large letters

forming an inscription on the facade suggest it was dedicated by the
ill-fated grandsons of Augustus, Gaius and Lucius Caesar. It stood in
the centre of the Roman colony, in its own courtyard which was an
extension, across the main road, of the open courtyard of the forum.
It formed the Capitolium, the temple of Jupiter Capitolinus. This
arrangement of principal temple to Jupiter in conjunction with the
forum area is repeated over and over again as a standard type in these
western Roman cities. The craftsmanship is excellent. It falls short of
the temples in Rome only because of the non-availability of white
marble, but the substitute, a good quality hard limestone, made poss-
ible the same details of carved decoration, the drafted edges of the
ashlars for its walls, the same patterning on the mouldings which can
be seen at Rome; indeed, from its better state of preservation, it can
be used to illustrate the appearance of the temples in the capital, rather
than the reverse. It is impossible to say where the workmen came
from; if not from Rome itself, they were possibly recruited in Mar-
seilles, which still flourished as a Greek city and a centre of Greek
education for those Romans who could not afford the high cost of

Fig 66 *The Pont du
Gard, Nîmes.*

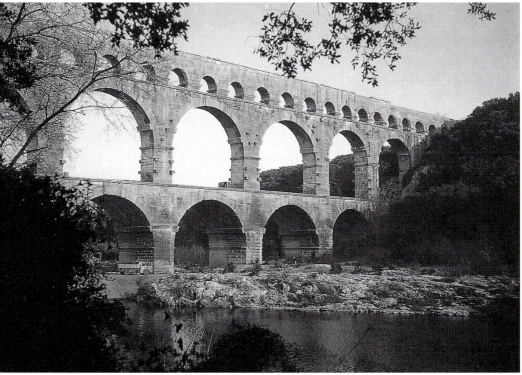

Athens. The temple dedicated by Claudius at Colchester was an even more splendid example, having a facade of eight Corinthian columns. Only the mortared substructure survives, forming the basement of the Norman castle there. Again, craftsmen must have been brought to Britain, perhaps from a skilled pool which by this time would have existed in Gaul.

Other buildings at Nîmes include a substantial arena, with two storeys of arcading for its exterior, rather than the three of the Colosseum. There is another, similar arena at Arles; both were achieved in stone, with some mortared work, rather than the full concrete technology of Rome. Both were well preserved because they were incorporated into late and post-Roman defensive systems. Both are restored enough (with temporary sections as necessary) for them to function as arenas at the present day, for the local version of bullfighting popular in southern France. It is instructive to see (as I once did, having come into Nîmes on such an occasion) how efficiently the Roman system operated for admitting, seating and, at the end, dispersing the crowds. The large number of passageways within the substructure of the building, the circular corridors and, above all, the numerous points of entry at different levels into the auditorium itself, combined with the distinctive numbering of the blocks of seats and the separate places of entry for each of them, is far more effective than the average British football ground or theatre.

Another aspect of the architecture of Nîmes directly influenced by Rome is the provision of water supply. This consists of a diversion point at the highest practical level of the town, where the water is directed into a series of pipes which brings it to the lower parts of the city. To bring water to the city itself, a source was tapped at some distance, and a channel for it cut at the appropriate level. At one point this had to cross the valley of the River Gardon, and this was achieved by one of the most splendid of Roman aqueducts, the Pont du Gard, a masterpiece of practical arcaded construction. It is not exactly like the aqueducts of Rome, which are extended at elevated levels on such arched structures for more continuous distances over the plain of Latium; but it is an excellent example of the incorporation of Roman technology into the development of the new provinces. At the same time it should be noted that in all provinces the Romans avoided the

expense of such structures by bringing water wherever possible – as for the greater part of the Nîmes system – in rock-cut or built channels at ground level, or even in pipes of wood or lead.

Gallic theatres, gates and bridges

There are other examples of metropolitan Roman architectural form in the western provinces. Theatres of the developed Roman type with semicircular auditoria, often resting in part at least on arcaded substructures, are frequent, particularly in the southern cities of Gaul. Again it is a Gallic example, in the Roman colony at Orange, which serves as the illustrative type, being better preserved and more accessible than even the best-preserved theatre at Rome, that of Marcellus. It is directly comparable with the theatres of Pamphylia, but differs from them (as it seems do all western theatres) by having the front of the stage building, facing the stage, decorated with a screen which

Fig 67 *The Pont Flavien at St Chamas.*

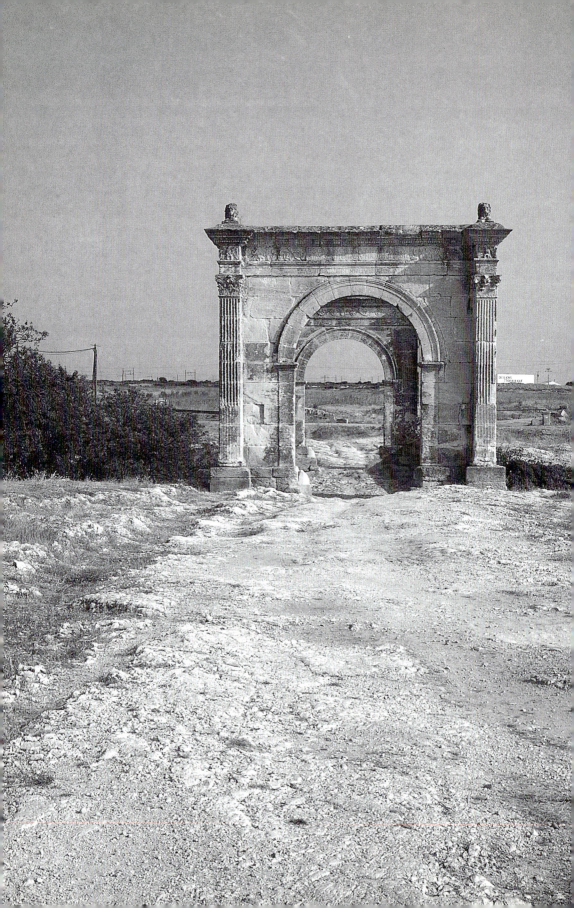

covers a series of projections and recesses, rather than the flat screen of Aspendos and Perge. Further north, Augustodunum was clearly a city with excellent classical architecture, though in this case it was not a Roman colony. Its gates were of developed three-arched type, with a gallery above, decorated with Corinthian pilasters and entablature. Such gates, often incorporated in later fortifications, survive frequently in Gaul. There is a large example (minus its gallery storey) at Rheims, with good carved decoration, particularly for the under-surfaces of the arch vaulting; and an excellently preserved gate, though rather late and coarse in detail, at the frontier town of Trier, in the province of lower Germany (though this is a place which, with the late division of the empire into separate areas of authority, became an imperial capital rather than a provincial town).

Bridges are another achievement of classical form in the western provinces. Solidly built of arched construction, they are often well preserved and even (at Vaison in Provence) serve to support a modern road and its modern motor traffic. The most delightful example is the Pont Flavien, near St Chamas, a single span over a not too large river, but with decorative arches, having engaged columns and an entablature, at either end surmounted by lions.

Romano-Celtic temples, theatres and houses

Not all the architecture, by any means, in the provinces of the north-west is of conventional classical type, and the region developed new strong local characteristics alongside those introduced into it from the centre. A distinctive form of temple occurs, so widespread in the Celtic regions that it is referred to as 'Romano-Celtic'. Its origin seems to be local adaptation of the Roman temple concept in line with vernacular structural form and – originally, before the Roman conquest – materials (timber and wattle and thatch probably, rather than stone and terracotta tile). These have a square, or occasionally circular, high tower structure as the central element, the cella, surrounded by a verandah of similar plan, a lean-to roof running up to the tower which projects above it. Some are substantial. There was, for instance, one built from quite large blocks of stone at Coleshill near Birmingham. One of the biggest is the so-called 'temple of Janus', of which only the

Fig 68 Opposite *The arch of the Pont Flavien at St Chamas.*

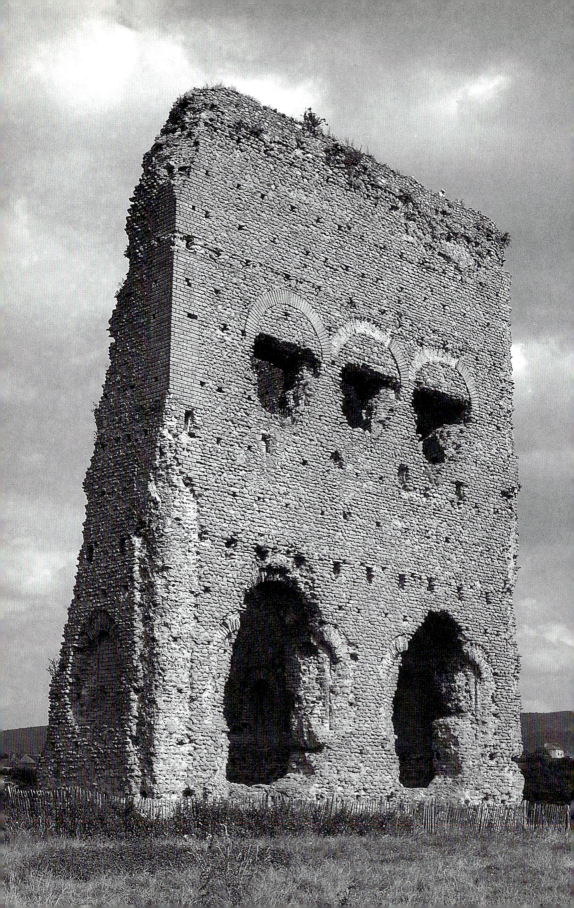

entral tower survives, standing just outside the walls of the otherwise lassical city at Augustodunum. Here the juxtaposition is striking. More easily understood is a modified form of theatre, found in the reas remoter from the Mediterranean. This combines the function of he theatre and amphitheatre, which in the Roman colonies of Provence, and certainly also at Augustodunum (though the amphitheatre there has been destroyed), required the same separate structures s metropolitan Rome. The centre is an arena, small in comparison with those of the great amphitheatres, but kept safely separate from he auditorium and entered directly from outside by passages. This nay be elliptical in plan, as in true amphitheatres, or more a circle, n interesting (but certainly unconnected) reversal to the orchestra of he Greek theatres. The seating is interrupted at one side, though it xtends beyond the axis of the arena (again, like a Greek theatre). At he interruption, a small stage building would stand, in some examples ossibly linked to the auditorium in the manner of a proper theatre. Construction of the auditorium more usually depended on banking up n earthen support for seating by means of continuous terrace walls. The motive for these hybrids is quite clearly economy, both in the tructure and, probably, the expense of the displays put on in them.

There are other variations of construction method. The temple of anus at Augustodunum is typical of many north-western buildings n being constructed not of carefully fitted large squared ashlars in the echnique of classical Greece, but rather of small blocks conspicuously nortared together and not requiring the absolute regularity of true shlars. There are advantages in this system. The small blocks are asier to quarry, and much less expensive to trim to size and shape. They are much more easily manhandled; the blocks can be lifted by n individual by hand, whereas large ashlars are so heavy that they equire block and tackle. In this, they come closer to the function of aked brick in Roman architecture; small blocks were used in much he same way, as facing for rubble concrete (made, of course, with me mortar, not pozzuolana), and were probably cheaper than brick n areas where they could be quarried readily. It is a technique used y the Roman army – Hadrian's Wall is essentially built of mortared mall blocks – and it may well have been army engineers who introuced it to the north-west as part of the deliberate Roman policy of

Fig 69 Opposite *The 'Temple of Janus', the core of a large Romano-Celtic temple at Autun.*

Fig 70 Opposite *The
principal temple
(Capitol) at Dougga in
Tunisia.*

urbanisation. Certainly, there was use of military craftsmen for at least the early building in Romanised Britain, though the idea that the 'town centre' element in the planning of cities – the temple, temple courtyard, forum and basilica – is derived from the planning of the headquarters buildings in a Roman legionary fortress is misguided the inspiration being rather the courtyard structures of Rome and their Hellenistic antecedents.

Timber was used abundantly in the north-west. Many buildings particularly houses – which have stone footings, would have carried superstructures which were of half-timbered construction. Brick was relatively rare, though tile-manufacture flourished even in Roman Britain. Again, there was a local alternative; roofs were often made of diamond-shaped slabs of stone (not true slates), quite thin, easily handled, forming scale-like roofs when nailed in an overlapping pattern by single nails at the top of the diamond. Again these were an economy, cheap to make, lighter in weight and requiring less elaborate support and timbering to form a roof. On the other hand, this can be combined with the amenities of Roman architecture; these houses often had underfloor heating, based on the hypocaust system used, naturally even in the non-monumental bath buildings of the north-west Interiors were stuccoed and given painted decoration, and, in the important rooms, floors were decorated with mosaic pavements, which could reach considerable dimensions and artistic complexity, but which more frequently were rather simple in design and construction.

North Africa

Materials had a certain prestige and this encouraged the element of universality in Roman architecture. In certain circumstances regionalism was overcome by a wider appreciation of quality. In part this was encouraged by the emperors, particularly as they came, in the second century AD, to originate from provincial rather than metropolitan families. Emperors gave buildings to cities that concerned them, that were their place of origin. The effects of this can be seen in particular at one of the North African cities, Lepcis Magna in Libya Western North Africa was taken by the Romans from Carthaginian control, and had a mixed population consisting of the original indigen

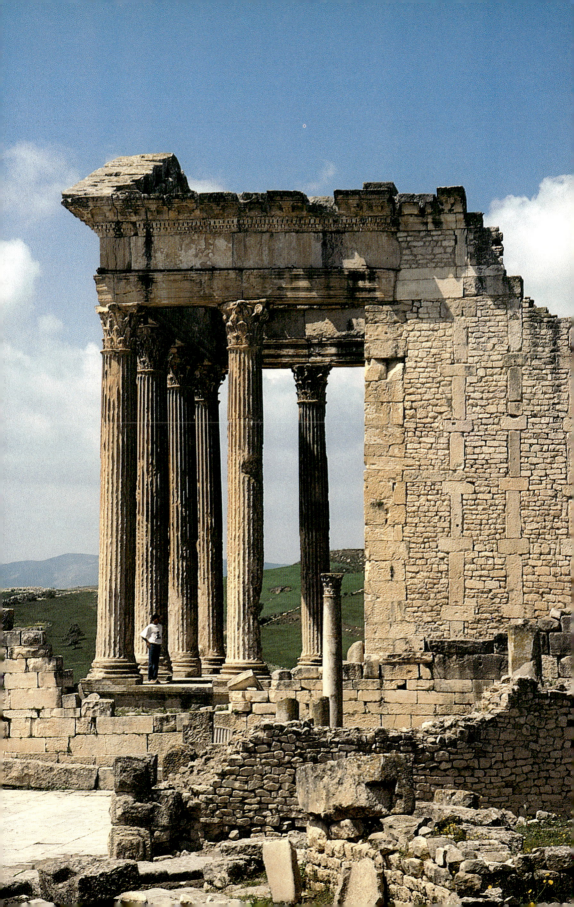

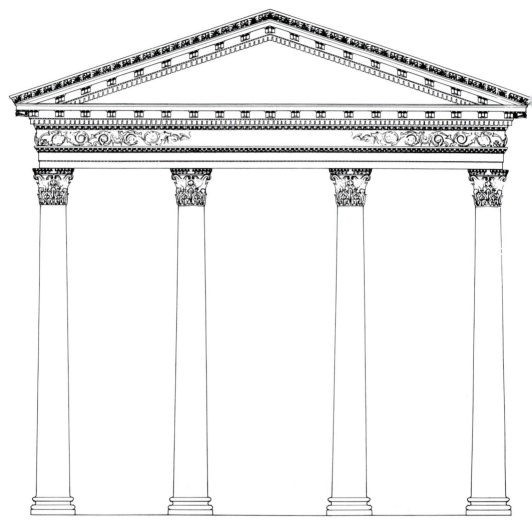

ous inhabitants, the descendants of Punic settlers, and, from the firs century BC onwards, Roman colonists. These different elements con tinued and Punic was still a spoken language in the area in the third century AD. The original architectural impact is less clear.

Carthaginian architecture is not clearly defined, and little of i survives to an extent where it can be appreciated. Excavations at Carth age are revealing more, including evidence for a complex dockyard fo the Carthaginian war fleets of quinqueremes; although the working arrangement is known – a circular island construction with slipway up which the ships would be drawn out of the water (which correspond closely to the trireme sheds at Piraeus) – the form of the roofing an

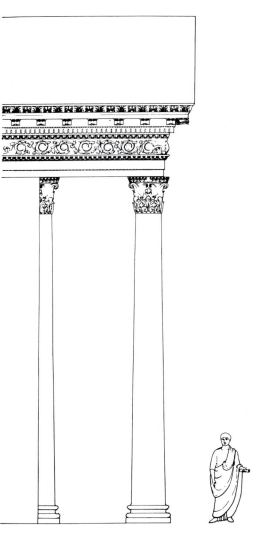

Fig 71 *The Corinthian temple, Knossos. This is a restoration, by Sara Paton, of the dismantled elements found subsequently incorporated into a late Roman tomb.*

other superstructure is far less certain. Equally, we know that Carthage was strongly fortified and was in every sense a formidable city; but, just as architecture in the Phoenician homeland does not appear to equal that of contemporary Greece, so any monumentality at Carthage eludes us. When we begin to pick up the evidence for architecture in western North Africa, apart from some tomb structures that may have been influenced directly by Hellenistic concepts, what is seen is, as in Gaul, a provincial off-shoot of metropolitan Roman concepts. Lepcis developed rapidly. It had temples of Roman podium type, and a theatre was constructed in the first century BC, the gift of a local inhabitant whose Roman status and name does not exclude his Punic

origin and final name. The town increased considerably in size, and its main axial street extended further and further from the harbour which was the origin of the place; new extensions were marked by the creation of arches. All this was built in the good local limestone. It gives the impression of a Roman place, solid and architecturally coherent, its buildings derived from those of Rome, but not completely echoing its splendour. This can be seen over and over again in the cities of North Africa – podium temples, a capitolium with its own courtyard as an extension of the forum. They contain theatres and amphitheatres – examples at Timgad are certainly on a scale comparable with those of Provence, if not of Rome itself. There are more paved streets, more arches at extensions to streets, and all of it built in the accepted western classical style in the local building materials.

In the second century AD this begins to change. More and more, marble elements begin to be employed in the design. This is not simply a matter of importation of blocks of marble as building material to be handled by local craftsmen. Already in the time of Hadrian, and probably earlier, architects in Rome had been importing finished columns in exotic stones, such as the granite quarried in Egypt. A trade developed in ready-made, prefabricated architectural elements. An excellent example has been found of a temple facade in the Corinthian order, from Knossos, later re-used in a tomb; made in Athens, the pieces were carefully labelled so that there would be no mistaking their position in the original temple design and they could be properly erected in Crete. The quarries of white marble on the island of Proconnesos in the Sea of Marmara (whence the sea takes its name) specialised in the production of ready-made architectural elements which could then be incorporated by local architects into their designs. Shipwrecks with cargoes of these elements have been found off the coast of North Africa, and buildings employing them still stand. Often the marble is little more than a facade, particularly suitable for temples of Roman type, and certainly the expense of transport meant that marble could never replace the local stone as the basic building material. Certainly, it must have become extremely expensive at a distance from the harbour town. Lepcis, being a wealthy harbour town – it was the outlet to the Mediterranean for the exotic creatures of Africa, imported for games and shows – and having imperial favours from Hadrian and even more,

later, as the birthplace of the emperor Septimius Severus, built much more lavishly in marble. A bath-building was given by Hadrian, using local stone for the basic structure, but with considerable use of marble and other impressive stone to adorn the interior. Above all, there was the new forum and basilica constructed by Septimius Severus, in which the work of craftsmen from the East, from Asia Minor if not from the Syrian mainland of Septimius' wife Julia Domna, creates not only echoes of the metropolis, but indications of the universality of Roman architecture. Lepcis is a special case. On the whole, in all Roman cities, local traditions and concepts prevail. But behind them is a universal line of development, of a classical tradition begun by the Greeks, enhanced by the Romans, and handed on, in changing but continuous line of descent, to their Western and Byzantine successors.

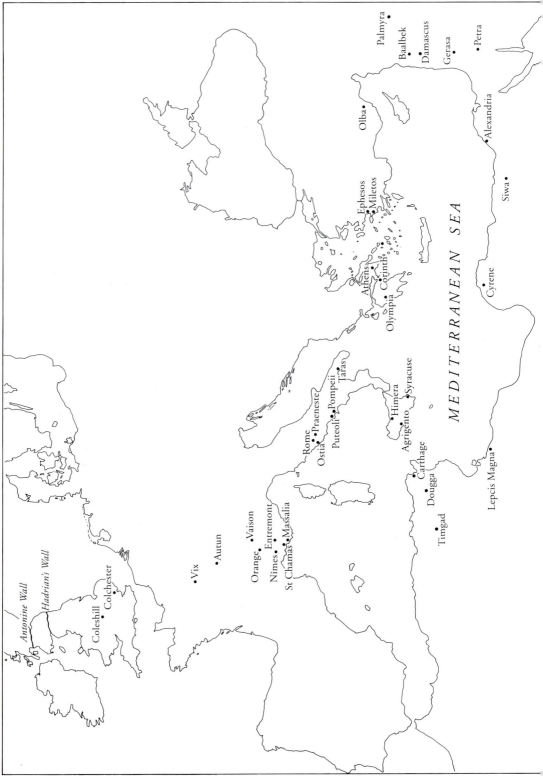

MEDITERRANEAN SEA

Ankyra

Aspendos
Side
Perge

Aphrodisias
Magnesia
Euromos
Lagina
Ephesos
Halikarnassos
Priene
Samos
Miletos

Pergamon
Aigai

Proconnesos

Knossos

Emporio

Naxos
Delos
Paros

Lefkandi
Eretria
Rhamnous
Sounion
Athens
Aigina
Epidauros
Perachora
Tiryns
Olynthos
Delphi
Sikyon
Corinth
Megalopolis
Pella
Olympia
Vergina
Thermon

Glossary

abacus
The upper section of a capital.

Aeolic
A variant form of Ionic capital, with the volutes springing from a central triangle, rather than joined across the capital. Obsolescent by the fifth century BC, and limited to the north-east Aegean area (Aeolis).

agora
The central open space in a Greek city, equivalent to the Roman forum.

amphitheatre
An arena, normally elliptical in plan, and the surrounding seating; used in the Roman world for gladiatorial, animal and similar contests.

architrave
The beam (normally stone) supported directly by columns.

atrium
The inner part of a Roman house, surrounded by rooms which open off it, and lit by an opening in the roof.

cella
The main room of a Greek or Roman temple (the Greek equivalent is 'naos').

Corinthian
The 'third' order of classical architecture, derived from Ionic but using instead a more ornate capital formed from a bell section decorated with carved acanthus leaves. For its form see fig. 8.

Doric
The order of Greek architecture which developed in the mainland of Greece. For its form see fig. 8.

echinus
The spreading section of Doric and (though less visible) Ionic capitals.

entablature
The entire superstructure carried by colonnades and consisting of an architrave and frieze, surmounted by a cornice.

fluting, fluted
The series of vertical channels cut into the shafts of columns.

forum
The central public open space of Roman cities, equivalent to the Greek agora.

gymnasium
Originally an open space near (but generally outside) Greek cities where the males exercised naked to train as soldiers; by the Hellenistic period generally transformed into schools or (exceptionally) the equivalent of universities, and after, buildings appropriate to these functions.

hekatompedos
Greek term meaning 'hundred footer', that is, a temple of (approximately) that length.

hypocaust
Roman system of heating, by admitting hot air from an adjacent furnace in a space under a floor supported on low pillars of stone or superimposed tiles.

Ionic
The order of Greek architecture evolved in the islands of the Aegean and the coast of Asia Minor, using volute capitals. For its form see fig. 8.

megaron
The main hall in the palaces described in the poems of Homer, and so the term used by archaeologists for the actual halls and similar rooms of Late Bronze Age palaces, square or rectangular with side walls prolonged to form porches.

metope
The flat square sections (separated by triglyphs, q.v.) which form the frieze of a Doric entablature.

mutule
Rectangular slabs on the underside of the horizontal cornices of Doric buildings, usually decorative with three rows of six pegs, or 'guttae'.

pediment
The gable end roofs, especially of temples, which contain sculptural decoration.

peripteral
Temples completely surrounded by columns.

podium
The raised base on which Roman temples stand, approached by steps at one end only.

pseudo-dipteral
A temple with space for it to be surrounded by two rows of columns (i.e. dipteral), but with the inner row omitted.

pulvinated
Wall blocks given a curved or 'cushioned' vertical outer surface.

stoa
A Greek building formed essentially from an extended colonnade and portico, often with rooms behind, and possibly more than one storey.

triclinium
Literally, 'three couches'. A term for Roman dining rooms containing three large couches, one to each side, one at the back, on which diners reclined with their heads towards the central space.

triglyph
The rectangular section, decorated with vertical grooves, separating the metopes (q.v.) in the Doric frieze.

Further Reading

General books

Boethius, A., *Etruscan and Roman Republican Architecture*, Harmondsworth, 1981.

Dinsmoor, W. B., *The Architecture of Ancient Greece*, London 1950.

Lawrence, A. W., *Greek Architecture*, 5th edition, London, forthcoming.

Sear, F., *Roman Architecture*, London, 1982.

Ward Perkins, J. B., *Roman Imperial Architecture*, Harmondsworth, 1981.

Particular aspects

Blake, M., *Ancient Roman Construction in Italy*, Washington, 1947.

Coulton, J. J., *Greek Architects at Work*, London, 1977.

Davies, P., Hemsoll, D. and Wilson Jones, M., 'The Pantheon: Triumph of Rome or Triumph of Compromise', *Art History*, 10, 1987, 133–53.

Macdonald, W., *The Architecture of the Roman Empire*, New Haven and London, 1965.

Tomlinson, R. A., *From Mycenae to Constantinople*, London, 1992.

Tomlinson, R. A., *Greek Sanctuaries*, London, 1976.

Photographic Acknowledgements

The illustrations are the copyright of R. A. Tomlinson, except for:

1 Oxford University Press
4 Penguin Books
6 © Trustees of the British Museum
7 © Trustees of the British Museum
8 Henry Buglass, Department of Ancient History and Archaeology, University of Birmingham
10 © Robert Harding Picture Library
12 Alma Tadema collection, Birmingham University Library
13 © Trustees of the British Museum
15 © Trustees of the British Museum
16 © Trustees of the British Museum
17 © Trustees of the British Museum
18 Alma Tadema collection, Birmingham University Library
19 German Archaeological Institute
20 Deutscher Kunstverlag

23 De Gruyter, Berlin
26 © Trustees of the British Museum
27 © Robert Harding Picture Library
29 British School at Athens
32 © British Museum Press
35 Alma Tadema collection, Birmingham University Library
44 © Robert Harding Picture Library
46 British Museum Press
50 © A. W. Rogers
51 © A. W. Rogers
52 © Robert Harding Picture Library
55 Nick Tomlinson
57 Österreichisches Archäologisches Institut
60 Chatto and Windus
71 Sara Paton

Maps by Henry Buglass (see 8, above)

Index